JUSTINA M. BARNICKE GALLERY

22 November 2008 – 25 January 2009

CAMBRIDGE GALLERIES

17 January – 1 March 2009

MACDONALD STEWART ART CENTRE

17 January – 22 March 2009

JAMES CARL **DO YOU KNOW WHAT** A SURVEY 1990–2008

Contents

Foreword

do you know what, the first major survey of James Carl's sculptural and graphic work, is presented jointly by the Justina M. Barnicke Gallery, University of Toronto, Toronto, Ontario; Macdonald Stewart Art Centre, Guelph, Ontario; and Cambridge Galleries Queen's Square, Cambridge, Ontario.

The three exhibitions are the result of a longstanding conversation between the artist and the curators. By combining old and new sculptures, signage, photographs and archival materials, each venue counterposes various media, shifting economies, simulations and dissimulations in Carl's continued output. Taken together they offer an opportunity to consider a significant cross-section of the artist's work.

Long acknowledged by his peers, James Carl has produced a sizeable and influential body of work. Born in Montreal in 1960, Carl spent much of the 1980s and 1990s in a state of transience, travelling throughout North America and Asia and studying at the University of Victoria, McGill, Rutgers and the Central Academy of Fine Art in Beijing. In 1999, following several years in New York, he settled in Toronto in order to assume a teaching position at the University of Guelph. His work has been shown in numerous solo and group exhibitions in North America, Europe and Asia.

At stake in Carl's material world are the zones between the public and the private, and between contents and containers—considerations which form the rhetorical grounds for the texts in this volume. Barbara Fischer's essay points to the attributive potential of sculpture in a cultural economy of meaning, suggesting that Carl's work undermines stable identities through its strategies of evacuation and nomination. The inversion of expectations that are implicit in Carl's work are contextualized by Ivan Jurakic as a desire for "dispassionate clarity"—a productive form of doubt—one with philosophical precedents East and West. Robert Enright, in turn, unpacks the numerous art historical inferences implicit in Carl's contemplative oeuvre, locating caches of devalued cultural currency in his polymorphous product.

We are privileged to have had this opportunity to partner together to present this unique multi-venue survey of Carl's work. We would like to take this opportunity to thank the Canada Council for the Arts, Ontario Arts Council, Toronto Arts Council, Musagetes Fund at the Guelph Community Foundation and Diaz Contemporary.

Barbara Fischer	Judith Nasby	Mary Misner
Director/Curator	Director/Curator	Director
Justina M. Barnicke Gallery	Macdonald Stewart Art Centre	Cambridge Galleries

Some Assembly Required

Ivan Jurakic

Nothing is in itself more this than that

—Pyrrho of Elis

James Carl makes uneasy ciphers. His sculptures, public interventions and graphic works strike an anxious balance between familiarity and formalism. Constructed from unexpected yet common materials, the work deliberately inverts expectations: valuable commercial products are fashioned out of recyclable materials like cardboard; non-bio-degradable food containers are painstakingly carved out of solid marble; and venetian blinds are handwoven into free-form abstractions.

Over the years Carl's projects have accumulated into a doubtful line of consumer goods, ranging from appliances to trophies, power tools, audio gear, automotive tires and office supplies. It is an inventory that mimics the ubiquitous items that litter our homes and garages. However, the absence of branding or logos in Carl's work separates these objects from their commercial counterparts by rendering them anonymous. By contrast, the unexpected craftsmanship and precision that the artist exerts in his meticulous reconstructions turns on its ear the concept of planned obsolescence typically associated with disposable products.

Carl does not transform materials as much as fold them from one state into another like so much conceptual origami. Whatever illusionistic *vérité* he achieves through the adaptive reuse of materials is predicated on the fact that the works never pretend to be anything other than what they are: replicas, duplicates. These deceptively simple counterfeits conform to the Baudrillardian theory of simulation, or "third order simulacra" in which the copy replaces the original to reveal the underlying construction of meaning.[1]

What distinguishes this work from recent anti-consumerist culture jamming is its rigour. Carl's products don't just mirror the consumer items they appropriate but use an implied surplus to infer a deficit. His works point towards a zenith of emptiness. Referring to this "tendency to expend an incommensurate amount of care in the replication of otherwise dumb objects,"[2] we get a sense of the contradictions at play. The work is

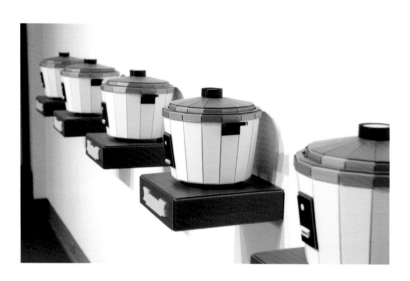

dynasty 2000

anything but dumb, but it immerses itself in the mundane in much the same way that the popular sitcom *Seinfeld* claimed to be a show about *nothing* despite the underlying intelligence of its writing. Carl uses a similar conjuring trick to make artworks that are essentially empty. Even when his forms are solid, as is the case with the marble *takeouts* (1995–ongoing), they contain nothing.

His sculptural series *dupes* (1999) features three free-standing reconstructions of service terminals—an ATM, a baggage X-ray machine and a courier deposit box—fashioned out of cardboard. Commonly found in shopping malls and airports these life-size props are analogues of the original artefacts and evoke familiarity and use. We can readily imagine making a deposit, waiting for luggage or dropping off a parcel at the end of the business day, but the lack of any functioning interface hints at the increasingly depersonalized nature of these transactions. As service terminals inevitably replace people, Carl's *dupes* remind us of the amount of time spent in front of automated kiosks and the manner in which each new technological advance seems to reiterate our role as consumers rather than citizens. If a duplicate is a reproduction or double, a dupe is simply someone who has been fooled and taken advantage of.

dynasty (2000) is a series of five life-sized wall-mounted rice cookers constructed out of a form of corrugated plastic that is typically used in commercial signage. The title and number of appliances corresponds to the Five Dynasties of northern China (A.D. 907–960), a period marked by military upheavals, the persecution of Buddhism and the introduction of a paper currency. Carl's rice cookers take on added significance with the recent emergence of China as the single largest exporter of goods to the North American marketplace. By equating contemporary China with the upheavals of an earlier dynastic period the work seems to suggest a reproving narrative about the pitfalls of unregulated global expansion at the expense of social and environmental reform. At the very least the rice cookers serve as problematic icons of our seemingly insatiable appetite for inexpensive labour and cheap consumer goods.

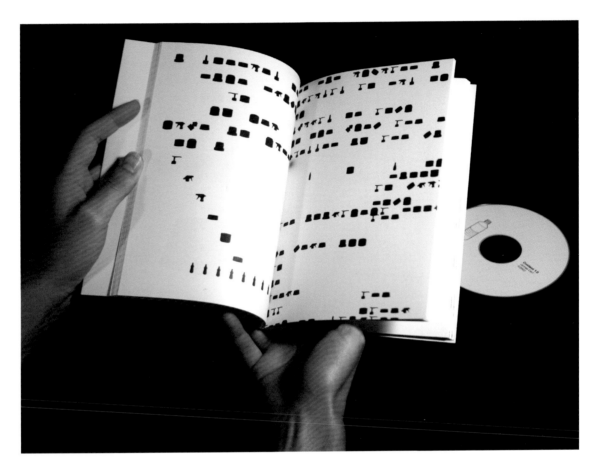

content (1997–ongoing) is an inventory of 100 computer-generated icons of generic water bottles, detergent containers, atomizers and bottle caps. Arranged in a code of outlined, bold and solid patterns, the images combine to form a pictographic cipher that infers collection and recycling. While increases in our daily consumption of bottled water in particular have lead to the overcapacity of recyclable materials in landfills, the artist's use of the iconography of the water bottle suggests a disconnect between water as a necessity and a commodity. Living alongside the Great Lakes, the globe's largest inland source of fresh water, it is easy to take water for granted and forget that throughout the developing world potable water is a finite resource that people routinely forage

content 1.0 2002

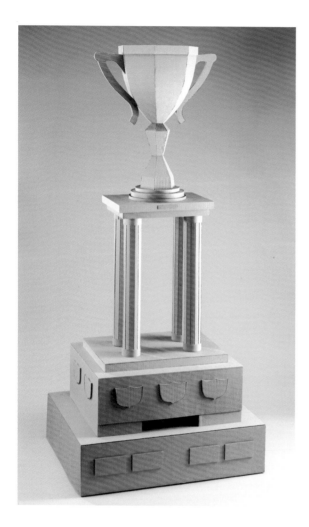

a trophy (for Tom Dean)
1996

for using recyclable plastic containers.³ Ironically, if we put a soft emphasis on the first vowel in the title of the work—*kən'tent*—its meaning implies a state of contentedness or appeasement that suggests complicity.

These contradictory shifts in meaning course like an alternating current through Carl's work. In *Sculpture in the Age of Doubt*, Thomas McEvilley suggests that postmodernism runs counter to "the law of the excluded middle," which argues that any position taken must be either true or false, that there can be no position in between. Using the example of Pyrrho of Elis (c. 360–275 B.C.), McEvilley confutes this law by suggesting that one can establish "a position that is neither affirmation nor negation but a kind of attention that is neutral and impartial while remaining alert and vivid."⁴ McEvilley further suggests that this sort of philosophical "indifference" can lead to "imperturbability," a state of calm that allows for intellectual liberation and clarity. The seeming contradictions that power Carl's work—the deliberate confusion of meanings and materials—correspond with McEvilley's observations and suggest an attempt on the part of the artist to achieve a similar level of dispassionate clarity in his work.

Carl wisely uses these principles as a compass rather than a cudgel. We get his work because it represents things that we use or at the very least recognize. There is nothing mysterious or otherworldly about his choice of everyday objects as subject matter. The use of the everyday as an artmaking strategy appeared during the last century, but if we look beyond the obvious precedents set by Marcel Duchamp, Andy Warhol or Jeff Koons, we find an historical parallel in the tradition of the still life. Translated from the French *nature morte*, meaning literally "dead nature," we find a definition not far removed from the temperament of Carl's work. During the 17th century, Dutch and Flemish painters used familiar objects—for instance, a half-peeled

orange, an overturned goblet or burnt out candle stub—to create visual narratives that relayed the customs and morals of the period. These seductive tableaux used the commodities of their time to point towards the hubris of earthly wealth and the inevitability of corruption.

The strip mall may have replaced the brimming banquet table as a metaphor in Carl's work, but it strikes a similarly cautionary note. We may not have time to contemplate the ATM as a troubling spectre while making a withdrawal, but we might appreciate this same ungainly form when encountering it in a different context. Step back, take a breath and consider these silent transactions.

Notes

[1] Jean Baudrillard, *Simulations*, ed. Sylvère Lotringer (New York: Semiotext[e], 1983), p. 25.

[2] Excerpt from an interview between James Carl and Christina Ritchie in *Plot,* cat. (Vancouver: Contemporary Art Gallery/Open Space, 2003), pp. 24–5.

[3] Some of the same themes are suggested by the artist's outdoor installation *fountain* at the Toronto Sculpture Garden, 14 May–30 September 1997.

[4] Thomas McEvilley, *Sculpture in the Age of Doubt* (New York: Allworth Press, 1999), pp. 54–5.

Sculpture, Language, Economy

Barbara Fischer

The consistent element of James Carl's work is its sculptural and graphic engagement with things of the everyday world. That interest was already manifest with his astonishing debut exhibitions in Montreal in 1992, Vancouver in 1993, and Toronto in 1994, the city where he decided to settle after his undergraduate studies in Victoria and Montreal, intermittent travels and studies in Asia, and graduate work at Rutgers. Hosted in Toronto in 1994 by YYZ Artists' Outlet, Carl produced an ambitious series of life-size cardboard sculptures of common appliances—TVs, refrigerators, stoves, washers and dryers, among others—for an installation that straddled the then storefront gallery space and the adjacent Queen Street West sidewalk. Populated by the conducive, pre-gentrification mix of artists, mental health patients, veterans and hookers, the area's businesses consisted largely of second-hand shops and used-appliance stores for which the street was as much sales floor as refurbishing centre for the swapping of parts and cleaning of derelict equipment. It almost required a second take to recognize that Carl's appliances, meticulously cut and finished from salvaged packaging, were out of the ordinary in the very ways that they did and did not fit in with their surroundings. Seemingly new in their Pop-Minimalist simulation of box-shaped household appliances inhabited by chimerical content, the works blended into the environment, especially on those afternoons and evenings when bundles of cardboard were piled high on the street in time for recycling day.

The non-durable cardboard containers speak to the liquidity of our condition—here one day, gone the next. By obliterating function with pure surface, displacing the expectation of storefront "colour and shine" into brown monochrome, and setting up shop with the schematic sign of objects, Carl's exhibition *unentitled* elicited a reading of the hollow object forms for their sculptural presence, and provoked the question as to what might constitute interest in the evacuation of utilitarian content.

The survey exhibition *do you know what* presented a succinct sampling of more than fifteen years of Carl's sculptural objects and two-dimensional designs that refer almost exclusively to the pedestrian world of things. Starting with the early cardboard appliances, Carl's ongoing sculptural project has come to include a broad range of business supplies,

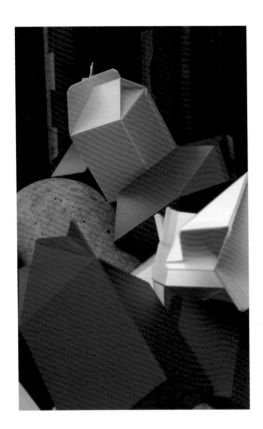

2% 1997

domestic hardware and consumer products. Portable methods of food supply (rice cookers, takeout containers, milk cartons, the six-pack beer case) meet studio tools (table saws, circular saw, dust buster and hand grinder), which blend into office supplies (binders, file boxes, newspapers, rubber bands), travelling on to the laundry and the bank, the ATM and the FedEx depot, and then back into the living room (T-shirts, slippers, TV, video cassettes and audio set-ups). The shorthand assembly of the various sculptural and graphic objects in this tripartite survey exhibition evokes the circumstances of a generic bachelor, someone like the artist perhaps, whose entrepreneurial, shop-related activities also include the need to organize the office, do laundry, get quick money and fresh coffee, or listen to music—all balanced within the broader contexts of the reconfiguration of industrialized economies toward the service and culture industries and the multifarious eruption of consumer products resulting from globalized trade.

Focused on a utilitarian storehouse of things, tools rather than fashion or luxury items, Carl's objects recall Duchamp's similarly utilitarian readymades—the urinal, bottle rack, snow shovel and coffee grinder—and the subsequent homages made in the late-20th century to that artist's blunt object appropriations, including Jeff Koons' vacuum cleaners and Haim Steinbach's running shoes, amongst others. However, these precedents to Carl's practice draw their particular power, at least in part, from the irony that "sculpture" could be made by dint of the discerning eye and its desire, rather than by the able hand. Excerpting a sample of ubiquitous things from the flotsam and jetsam of consumer goods and giving these objects a special pedestal, sculpture here operates largely by the shock of displacement and the de-contextualization of an object that otherwise remains functionally intact. On account of a newly found iconic status, it can now provoke free-floating readings in the orbit of aesthetic apprehension, much in the same way that diamonds on a skull sparkle in the world of the commodity.

A number of important early works by James Carl also involve the direct appropriation of mass-produced consumer objects and the renegotiation of their symbolic place in the world. However, his interest in the "material world" takes on quite different

questions about the role of sculpture, and ultimately, the status of the object in the aftermath of an infinitely expanded, post-industrial consumerist field. The *modus operandi* in Carl's outdoor, interventionist installations is transformation by way of serial and conceptual (rather than subjective) assemblage and, more importantly, by the re-use and recycling of specifically disposable objects toward new symbolic purpose.[1] Instead of conceiving of this activity as a redemptive one—as is the ethic of much assemblage—his is a rather acerbic commentary on that very politic: empty plastic windshield washer fluid jugs are assembled into an igloo in *spring collection* (1991), exposing the idea of recycling as fostering an all too easy, self-satisfied and rather hollow sense of participation in the greater social "good." A more recent work consists of hundreds of variously coloured sponges squeezed into the openings of a chain link fence, symbolically linking cleaning, collecting and the transformation of material into a higher concentrate (of dirt or ideas), while also blurring the divisionary function of an actual fence in a sports field between players/producers and audience/consumers. These works take as their principal object something that is either hollow—empty bottles and cans—or whose function is concerned with the absorption and emptying of content—the sponge.

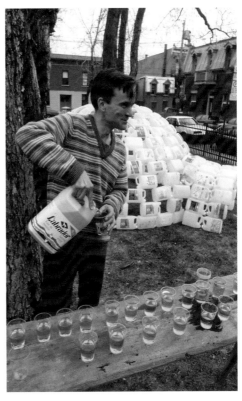

spring collection 1991

Carl's remakes, which include the cardboard appliances and which constitute the vast majority of his sculptural works to date, push that dialectic to a precision-tooled synthesis. Consider for instance the series of stone carvings *empty orchestra* (1995–2000), the title of which is derived from a transliteration of the word *karaoke*, and includes a video cassette, microphone, compact disc, cell phone and the unmistakable shape of a Sony Walkman. The objects mark both a particular historical moment and a personal biography, having their source in Carl's studies of the emergent capitalist superpower of post-Tiananmen Square China from the vantage point of a visiting art student (and one could say, participant in the "creative economy" of the post-industrial Western hemisphere).[2] The array of cheap electronics—continued in Carl's more recent carvings such as *subwoofer* (2006) and *deck* (2006)—invokes not only the memorable invasion of cheap products from Asia in the 1980s, and the consequent attrition of industrial manufacturing in the West, but also the ongoing

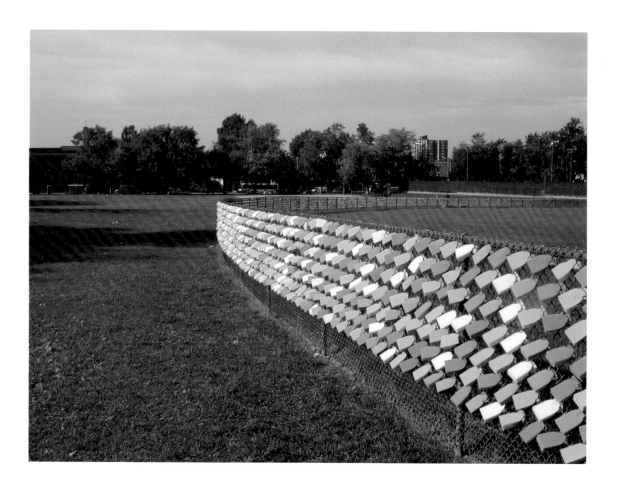

osmosis 2004

reality that these exports first drove the Japanese economy, and then those of Korea and China, to unprecedented heights. At the same time, once ubiquitous consumer technologies like the video cassette, Sony Walkman and even the compact disc itself, have slipped or are slipping into history—a circumstance strangely deserving of commemoration if one considers how short their lifespan was in the culture at large, and how great a role they played in the self-definition of generations and in the transitions of global economic power. Presented in a "fine art" material that denotes the historical form of portrait bust and public monument, the works in *empty orchestra* attach

an undying countenance to quickened obsolescence. The startling difference between these forms, and the fraught relationship between the rise of electronic technology and the role of manual labour, evokes not only the displacement of industry from Western economies to Asia and elsewhere in the world, but also, as the title of the work suggests, the rise of new cultural practices, such as karaoke and air guitar, which in the age of reproducibility set different terms by which to think through participation in the global creative economy. In the realm of labour, the act of carving (tracing the volume of an object from the outside in) may be to automation what karaoke is to recorded music.

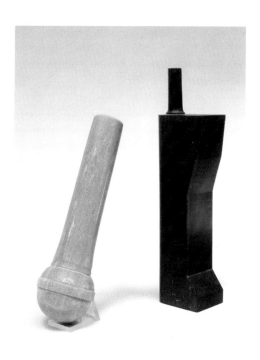

empty orchestra 1991

Shifting economies are also an integral part of an ongoing series of stunningly deceptive white marble *takeouts* begun when Carl was still a student in China. Here, the nearly unthinkable brevity of a Styrofoam cup or lunch container—used and disposed of sometimes in seconds and in unimaginable numbers—is shocked into exquisite marble permanence in Carl's full-scale replicas. I first encountered one version in the Toronto artist Yam Lau's refrigerator literally without seeing it: a friend had to introduce me to it by asking me to lift it, which at first I refused for fear of some explosive hoax. The startling experience of the stone's weight—forcefully countering the kinaesthetic memory of Styrofoam—presents another instance of the precise dialectical play by which Carl relates sculpture to the consumer world, or the consumer world to sculpture. Anticipating something to be light that is instead heavy reevaluates the economy of disposable versus lasting things. From Japanese and more recent new Chinese cinema, or from older Western and European documentaries, I carry images of metal lunchboxes, thermoses and cups used to transport homemade food. In Carl's work, enduring weight has been substituted for the time-saving disposable containers which, ironically, lean heavily on sustainability.

As with *empty orchestra*, both material and manufacture are enlisted into the economy of meaning. The very duration of their material and the act of carving (slow, methodic and intensely focused) is set against the tide of one-time use, the speedy life of the takeout and its immediate and monumental dispatch into garbage. The sculptures appear ready to stem the relentless loss of enduring possessions, a phenomenon that,

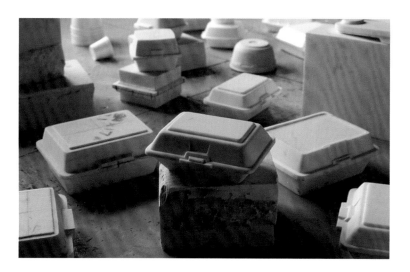

takeouts 1995-ongoing

according to Hannah Arendt, has a stabilizing function that anchors the ever changing nature of human life, allowing us to retrieve sameness, identity and a sense of continuity—a sense that withstands the otherwise permanent flux that characterizes human endeavour and especially the liquidating thrust of Western modernity.[3] However, rather than engaging in quixotic battle, the easy dispatch of permanence to the trash heap of modernity is weighed in symbolic form by Carl's carved sculptures. In their conversion to a symbolic domain, beyond the wear and tear of function, they remain as anchors to our apparent dilemma of identity.

Can *empty orchestra* and the objects from that larger series of remakes function as an overarching description of Carl's project, as his take on the world of the utilitarian object of manufacture? That is, can these sculptural objects represent a description of individual manual exertion reaching a state of near perfection (fullness) inside the sphere of reproduction?[4] Or from an obverse material perspective, do they describe a state of nearly perfect emptiness in the sphere of promised fullness or belonging in the world of consumption? A state of suspension in the universe of "the sign" from which we are suspended as if from desire itself, satiated only by temporary solutions, by fleeting satisfactions, always standing in reserve, always returning for more of the same?

The work's persistence is found in its pursuit of imploding equivalences. Carl's many graphic works are bare-bone and to the point. The most generic graphic equivalents for "T-shirt" or "bag" symbolize the objects onto which they are printed. Carl introduces the pun in sculpture as well: a cardboard beer bottle carrier, commonly used to transport a six-pack, is replicated in cardboard. These operations are not unlike that of Gertrude Stein's "a rose is a rose is a rose," or Magritte's pipe that is not a pipe (a motif that appeared abstracted on the poster for Carl's survey exhibition); or, its more recent Pop manifestation as Andy Warhol's *Brillo Box*—a plywood box that, according to its painted label, contains "24 giant boxes" of detergent and is as such a box of detergent that it is not, but certainly does not lack the (now hilarious or quixotic) conviction

of the consumer world as it disappears into the recesses of irony; or, the comparative conceptualism of Joseph Kosuth's early propositions where the presentation of an object, image and text of the "same thing" next to each other resulted in the evacuation of the stable identity of reference. The undermining of reference is articulated in the political sense in Carl's *fountain* (1997), a set piece of vending machines lined up to dispense, amongst existing brands, custom-labelled "James Carl" bottled water, remarking on the packaging of natural resources as an essential productive force in the capitalist information economy.

The "this *is* that" becomes the "this *as* that" in a kind of dialectical process of attribution that, in the realm of sculpture, is akin to the operation of language, of naming, and that underlies both the manufacture of consumer desire in the post-industrial world and the production of culture in the economy of reproduction. The sculptural and graphic object functions as a site of exchange—a switching device of surprise and betrayal, of fact and fiction, and of an oscillation between what separates and distinguishes both.

The question, "do you know what?" is thus rhetorical. The work opens the conversation. It poses a starter question, lying in wait to deliver a content that lingers in advance of the question. It pulls no punches when it supplies what alters the course of the conversation, or of an understanding. It invites a perceptual drift or shift: "Do you know what?...this cup is actually made from marble;" "I am a fridge... and I am cardboard;" and "These hundreds of rubber bands are not rubber bands...they are polymer clay." The object addresses us in a one-upmanship of our initial reading. Two simultaneous realities comment on and betray each other, and thereby foreground sculpture as the "medium" by which to interrogate substance and objecthood.

What a strange and surprising turn, to find that Carl's new works, exhibited under the title *jalousie*, precisely in their abstraction, suggest a sublimation of dialectically implicated oppositions. Woven in a strict pattern of three intersecting, mass-produced slats originally designed for the assembly of venetian blinds (angling, blinking strips of aluminum that open and close the face between inside and outside), these large and awkwardly limb-like volumes produce a precise, lucid and disembodied solidity. The weaving and peculiar bending re-invent the modernist dialectic between solid and negative space in sculpture, in the form of a flickering, nearly transparent volume of large, nearly weightless, but strongly tensile sculptures.

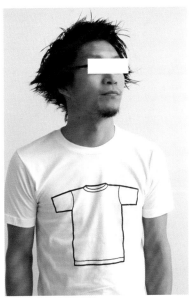

t-shirt t-shirt 2002

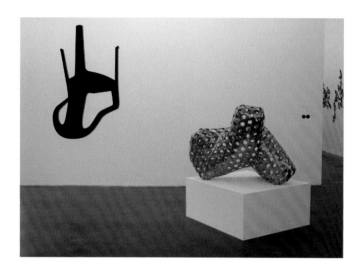

The works embody, this time in what seems a transubstantiated form, the many precise elisions of opposites in James Carl's practice: full as empty, throwaway as permanent, light as heavy, tensile as breakable, innocuous as pervasive, and even small as large, such as the monumental version of a beach ball in fibreglass that was temporarily installed at the University of Toronto's Blackwood Gallery, or the polymer clay replicas of a sparse sea of variously coloured, life-size rubber-bands titled *thing's end* (2008). In the latter, forgettable everyday things seen up close suddenly read as a field of monumental abstract sculptures, if not architecture.

Pre-modern sculpture evoked the internal logic of the human body by carving away stone to articulate a surface underneath, the "skin" seeming to suggest an inner muscle and skeletal armature. In these works, likeness, as has been argued, operated by way of a false idealism and empathy. If Rodin recognized the fiction that underlies the bond between inside and outside, appearance and substance,[5] in James Carl's new works the dialectic terms of open and closed, container and contained, solid and hollow volume, are literally woven into each other, their tensile force dependent on that weaving.

The stunning optical volume that they produce—with coloured slats interrupting the flow, its graphic and linear aspect flattening the volume temporarily, and the repetitive pattern causing constant perceptual oscillation (not far from Sol Lewitt's open grid cube)—is a kind of sublimated envelope, a description of outside butting against inside, an architecture of transparency and plasticity. Carl remarked how the material resisted his shaping, that it seemed to impose its will in the making of each entity. The slats bend on the basis of their material nature in certain limited ways, and to the extent that his hand would have to follow. The work measures a kind of oscillating, dialectical action between resistance, guidance and reaction. The sculptures suggest a hefty physical and material presence through scale, volume and even reference (one thinks of Henry Moore and Jean Dubuffet in particular), but as material and object they weigh very little. They have the subtle presence of the shell of an object, nearly its image rather than material presence. In fact, their airy opticality could be said to contradict the very idea of sculpture, but that contradiction is especially poignant here as

sculpture is represented by another kind of medium and an explicit short-circuiting of the anticipation of sculptural weight. Together they weave a metaphor for the transubstantiation of the object world in the economy of a mediating agent, one that governs how we look inside and see outside, through it and at it. Sculpture is suspended in the neither empty nor full, liquid nor solid, opaque nor transparent state, and quizzically hovers about as a "between," as the manifestation of "medium" in the form of "blinds" or, as Carl suggests, as an economy of jealousies.

Notes

[1] Shared to a certain extent by British artists such as Tony Cragg or Bill Woodrow.

[2] Carl reports that the monumental *Goddess of Democracy* was sculpted at the Central Academy just months before he would join the school's master class, and that Tiananmen Square was only a stone's throw away.

[3] Hannah Arendt, *The Human Condition* (Chicago: University of Chicago Press, 1998). See also Zygmunt Bauman, *Liquid Modernity* (Cambridge: Polity, 2000). A similar approach may be apparent in the work of the German artist Thomas Demand, whose photographs insist on the discrepancy between appearance and the handmade, paper-cut construction of the photographed object.

[4] See Walid Sadek, *Karaoke* (Liverpool: CAIR and Bluecoat Gallery, 1998).

[5] The thesis of Rosalind Krauss' *Passages of Modern Sculpture* (Cambridge, MA: MIT Press, 1981).

If We Know What Is Good for Us

Robert Enright

In 2006, Dave Eggers published *What is The What,* the fictionalized autobiography of Valentino Achak Deng, a Sudenese refugee and one of "The Lost Boys" who escaped the horrors of the civil war in his birth country in 1983. He was six years old, and before settling in America, he would spend 13 years in refugee camps in Ethiopia and Kenya. Deng's story, and its telling, is astonishing. Eggers invents a hybrid narrative form that is part novel, part documentary and part autobiography. Its title comes from a Dinka creation myth in which a man and a woman are offered a known commodity (in this case, cattle) and an unknown possibility, the "what." They choose the former, but because they don't know "what the what" is, they don't know what they might have had. The unknown "what" continues to vex them.

In the 1970s, Vija Celmins, the Latvian-born, New York artist, brought back some rocks from a trip she had taken to northern New Mexico. Initially, she carried them around in the trunk of her car, then she lined them up on her window sill, and finally she recognized that the stones contained galaxies. "They formed a set, a kind of constellation," she remembers, and at that point she decided to "put them into an art context. Sort of mocking art in a way, but also to affirm the act of making: the act of looking and making as a primal act of art." Her primal act was to make bronze casts of eleven of the stones, and then paint the sculptures to resemble the originals as closely as possible. The piece was called *To Fix the Image in Memory* (1977–82), and even on close observation, the bronze and stone versions are almost indistinguishable. Interviewed in 2003, Celmins further addressed the work: "It's a questioning piece: what does this mean, what is this?"

Taken together, Eggers and Celmins pose the kinds and degrees of questions that shift the interrogative into the declarative. It is a process of thinking that neatly corresponds to the way James Carl makes art. The title of his three-part survey exhibition, *do you know what*, was constructed as both a question and a statement. In its interrogative form, it asks us what we know, or rather, *if* we know "what;" in its declarative form, it *shows* us "what." But his naming goes beyond the matter of a specific declaration and becomes an open-ended gambit. As Carl points out, "The phrase, 'do you know what?' acts

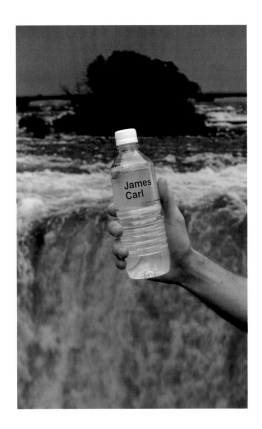

fountain (detail) 1997

as a kind of conversational opener used most frequently by children to introduce the fact that they would like to say just about anything." So it's a question that's not really a question at all. In fact, the most commonly accepted response to the question is, simply, "what?"

What are we looking at when we confront a dumpster made of cardboard, or a Styrofoam cup carved from marble? In questioning the phenomenological status of the faux objects he makes, Carl asks not only what are we seeing when we look at a cardboard replica of a dumpster, but what are we seeing when we look at a *real* dumpster? Carl's artistic project implicates the viewer in what amounts to an engagingly serious epistemology of doubt.

These questions circulate through the eighteen years of artmaking encompassed by his hydra-like survey exhibition *do you know what*. The artist might prefer the polyp to the serpent as a generating metaphor, since he has used it in describing an early public sculpture titled *fountain* (1997). According to Carl, the work "considers the polyp as a formal model," a sort of benign tumor that entered into a symbiotic relationship with the public garden in which it was situated. Installed in the Toronto Sculpture Garden, *fountain* consisted of nine vending machines decorated with a segmented, backlit image of Niagara Falls. Each machine dispensed bottles of water, some of which carried Carl's own customized labels. In his artist statement, Carl wrote about "the slippery divisions and distances that the contemporary sculpture garden embodies. It is a model space for a visual consideration of the distances between nature and culture, public and private, organism and machine. Equally, the garden evokes reflection upon the boundaries dividing introspection from circumspection, service from servility, the synesthetic from the anaesthetic, the hybrid from the mutt."

These are the binary categories that *fountain* negotiates. We are reminded that public fountains serve the social good through their physical attractiveness and accessibility. Then the work foregrounds Nature by replicating one of her wonders, Niagara Falls, as a covering surface that promotes the sale of water in plastic bottles. In the arena of modernist art history, the work also wryly picks its reference points. By naming a sculpture that deals with found objects and liquid *fountain*, Carl inescapably conjures

up the conceptual ghost of Marcel Duchamp and his artfully nominated urinal; just as a backlit image invites the living photographic presence of Jeff Wall.

Carl is aware that any act of sculptural production, whether for an outdoor public space or inside a museum or art gallery, is framed within an existing context of reception, a context that is self-recognized as much as it is historically-generated. This is less a problem of dealing with what has been called the anxiety of influence, as much as it is an embrace of what could be re-formulated as the reliability of influence.

Carl studied at the University of Victoria in the early 1980s in the hothouse atmosphere overseen by teachers like Roland Brener and Mowry Baden. But the situation he found when he moved to Montreal in 1989 was considerably different. "Nobody seemed to be *making* anything and those parallel galleries were like conceptual art morgues. I wanted to make stuff and I wanted people to see it. It wasn't anger that was legible in the work finally, or even reaction, it was more like pleasure and participation." Carl began to make objects out of cardboard—dumpsters and large household appliances such as stoves, refrigerators and washing machines—which he then left as discards in the street. Their engagement with play was a direct result of the discrepancy between what they represented and the material from which they were made. The viewer's pleasure came in that recognition. Carl tells a story about two trash collectors who took away one of his deliberately abandoned washing machines. He has photographs that show the workers leaning their weight into the appliance, picking it up as if it were real. He estimates the object weighed two pounds.

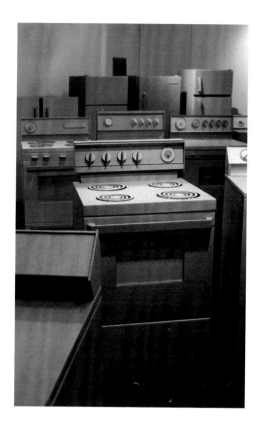

re:possession 1994

It is easy to identify with the problem anticipated by the movers. Carl titled three of the pieces in the Cambridge Galleries section of his survey exhibition *dupes*. They are cardboard versions of an x-ray machine, an ATM and a FedEx box, all made in 1999. As is usually the case, Carl's naming withstands considerable scrutiny. The first thing you notice is that the three life-size machines look as if they might have been carved from wood. That possibility leads you to appreciate one doubling captured in the title—in thinking wood before cardboard, we realize that we have been duped, not once but twice. (In one sense, we're correct, in that cardboard is what the sculptor

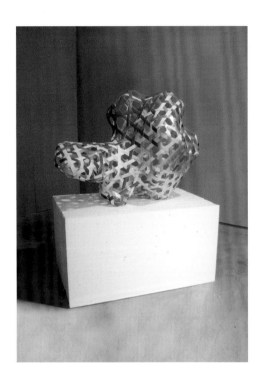

the space between angry lovers in a moving car 2006

Robin Peck felicitously calls the "pale memory of wood.") More directly, the title *dupes* is an abbreviation of the word duplicate; and beyond that it shares an etymological connection to duplicitous, a reading that underscores another way of measuring the effect of the art and the intention of the artist who made it. Then again, to duplicate something that people want is a good thing; but at the same time, it is a redundancy. In this shape- and meaning-shifting context it is the thing, the sculptural "what," that is the occasion and the site for speculation.

Much of the time, Carl's sculptures look simultaneously in directions which can be contradictory. If they're not in direct contradiction, one reading often undercuts the other. There are numerous examples in Carl's survey exhibition of this tendency operating in a minor key. In both the Justina M. Barnicke Gallery and the Macdonald Stewart Art Centre versions of the show, there are occasions when his reconfigurations go so far as to resist sense and logic. His "traffic signs" largely follow the look of functional signage, but they can be empty of useful instruction. The diptych of self-cancellation that runs *OKNOTOK,* a vacillation of affirmation and denial, puts you in mind of Ed Ruscha's self-erasing thoughts.

But there are deeper soundings in his looking at the world and making objects out of that attention. In his recent exhibition at Toronto's Diaz Contemporary titled *jalousie* (which ran concurrently with the survey exhibition), Carl used his characteristic complication of meaning and material to suggest a way of regarding not only his newest sculptures, but his entire survey exhibition as well. The word *jalousie* carries two meanings in French; jealousy, the emotion, and venetian blind, the material from which the sculptures were made. Beyond their material composition, the exhibition title also alluded to Alain Robbe-Grillet's 1957 novel, *La Jalousie*, a story about a man so afflicted with jealousy that the observed and the imagined become indistinguishable states of perception. Carl's reading of the book is one in which, as he told the *Globe & Mail,* "the narrator is a negative space at the centre of the thing." The sculptures in *jalousie* clearly deal with space and its comprehension. Carl's idea was to weave an external surface sufficiently compelling to invite the viewer to look into the interior space of the sculptures. Negative space was balanced by measurable surface; inside and outside became equally important. "The thing that interested me is precisely what you're

seeing," Carl says, "the availability of the interior space, the large perforations in the skin of the thing that allows you that visual access to the interior."

In his appreciation of Robbe-Grillet's novel, Roland Barthes praises the author's ability to "[keep] to the surface of things, examining without emphasis." Carl makes similar use of surface to seduce us into looking, through the three-way weave of the venetian blind, into the heart of the piece. Materially and sculpturally, these are among the most beautiful objects he has ever made. The larger multi-coloured sculptures, made me think of Frank Gehry and his Minneapolitan fish; the two smaller, silver pieces in the inner gallery, sitting on low pedestals, invoked the compression of superb early modernist sculpture. Significantly, Carl has been seduced by his own craft and unsudden art. He has admitted these works "thoroughly engaged several clichés about artmaking that I've tried to avoid." The genesis of these sculptures goes back three years and in as many countries; if we're lucky, much more time and distance will pass before Carl exhausts their utility and beauty.

Early on, Carl called his cardboard works *re:possession* and the title supports the weight of yet another complication. As Robin Peck has argued, Carl's cardboard boxes become "parodies of utopian modernism."[1] So the artist's title for this work concerns a simultaneous reclamation and repudiation of modernist practice and the kind of objects it produced.

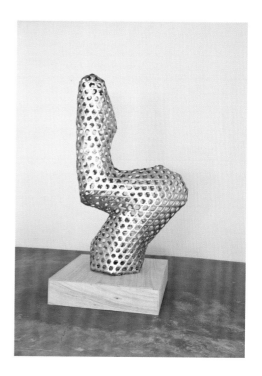

jalousie (pin) 2008

It's through this sense of vacillating enhancement and diminishment that we can read *office work '08* (2008), an array of seven sculptural stations in the Macdonald Stewart section of the survey exhibition. On one hand, the overall installation puts you in mind of a sculpture park. The separate configurations can be viewed as abstracted renditions of the ways in which sculpture can be deployed—as a column, a horizontal expanse, a figurative presence. Yet at the same time they have their own independent sculptural identity. *office work '08* is an assortment of commercially purchased "banker's boxes" on which Carl has precariously arranged hundreds of file binders in varying thicknesses. They are made from foamcore and adhesive vinyl. Their points of intersection and balance are ingenious and nerve-wracking; the column-shaped sculpture alone is sixteen binders high. You have a sense that at any moment any of the sculptures could come tumbling down like a house made from file cards.

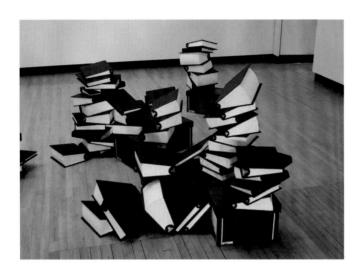

office work '08 2008

It's instructive to consider *office work '08* in relation to the largest sculpture in the Justina M. Barnicke Gallery exhibition, a virtuoso installation called *thing's end* (2008), comprised of thousands of rubber bands, or I should say fabricated objects that look like rubber bands. They are actually discrete sculptures made from polymer clay, hand-coloured, compressed in a pasta maker, rolled out, cut, and then baked in an oven at 250°C to purge the moisture. Carl describes it as "an arduous process" including what he calls the "observational moment" when he actually tries "to replicate some of the formal eccentricities you see in rubber bands that you've found on the street or brought home from the butcher." He insists that the closer you look, the more you will recognize inconsistencies with what you know about real rubber bands. In deference to his working knowledge, I remain skeptical. *thing's end* is an exhilarating piece, and still would be were it made with real rubber bands. But the painstaking method of its making puts it in an exemplary category of its own.

The nature of the installation adds to the richness of Carl's sculptural construction. The rubber bands sit on a white stage—a roomy pedestal sixteen by twelve feet at approximately bench height—and are placed in such a way that the viewer can sit on the fringes and closely observe the colour and texture of any one piece. Overall, the work achieves an intuitively registered balance between the white ground and the coloured objects that animate its surface. Carl imagines it might be perceived as "a wild model for a sculpture park, somewhere between Allan McCollum and Richard Serra."

Carl's gallery installations are artful in that every decision about conceptual, spatial and contextual relationships is carefully considered. Both the Cambridge Galleries and the Macdonald Stewart installations had distinct successes in this regard. In Guelph, the rich commercial red, green, yellow and black palette of *rastafries (super size),* a graphic rendition of two dozen fast food french fry containers made in 1997 from adhesive vinyl and corrugated plastic, was countered by the simplicity of *seven bottles* (2009), a series of piezo prints on paper rendered in austere black and white. This recent work functions as both a continuation of a pictorial language Carl has claimed

as his own—the font *content*, derived from shapes he created on the computer from 1997 and 2002—and an acknowledgement of the simple installations of bottles Tony Cragg made in the 1970s. Interestingly, Carl also quietly reprises the wall-attached ledges on which Cragg rested his bottles in the form of blackboard ledges fronting *alchemy* (1998), the artist's images of a pipe and a pair of slippers on masonite.

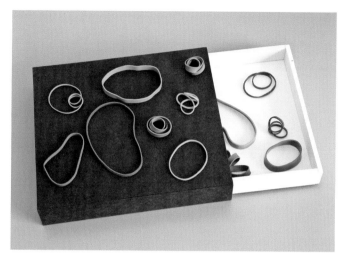

thing's end 2008

Throughout the almost two decades covered by his three-part survey, Carl's work consistently raises questions about economies of conception and execution. He can give exacting attention to any piece, or he can be utterly casual in his duplications. (In the Justina M. Barnicke Gallery exhibition, details on the surface of a cardboard TV made in 1994 are suggested by only a single raised knob, a flat disc, and some cross-hatching to indicate the speaker.) There is a kind of as-the-crow-flies aesthetic in much of this work, a sense that the piece should be made in the straightest line and with as much economy as possible. There are individual works, notably the rubber bands and the Styrofoam containers carved from marble, that are time-consuming, but within the process of their necessary realization, Carl still makes them in the most direct way possible. As he says in describing the cardboard works, "you don't have to do too much to generate that kind of gestalt recognition on the part of the viewer." In addition to the functional appeal of this simplicity of means, there is also a sense of personal satisfaction generated out of its logic. "Applying oneself to the material world in this way is an end in itself," Carl says, "making things with a serious-minded attitude has its own rewards."

While applied seriousness is an attitude that gets things made, it doesn't determine how they will be interpreted. The *dupes* raise a number of intriguing questions about representation; when you look at the back of the ATM machine the provisional illusion of the cardboard construction being a duplicate of a real bank machine breaks down. In sculptural terms, the ATM is a frontal piece and, unlike the x-ray machine, not a work that can be read as an all-round object. If you look at the base of the x-ray you see one of the cardboard wheels has "Distributed By" imprinted on it in red letters, and the bottom sheet has the caution, "Do Not Lay Flat" and "Careful Glass" stamped

dupes (x-ray) 1999

on the surface, along with logos for shards of broken glass. These siren calls from the real world are only visible if you get down on your knees and look under the piece, but they are reminders that Carl's intention was to make the faux piece out of the cardboard boxes in which the real appliance had been packaged. Often all that remains of his pieces from the 1990s is their photo-documentation. In one photograph included in the Justina M. Barnicke Gallery show, we can see his life-size dumpster next to an actual Smitty's dumpster. The lid is up on his version, and we can see that it was made from the packaging that once contained a range.

The umbilical relationship that the British sculptor Bill Woodrow was able to trace between source and finished product is similar to what Carl wanted to do with his shift from cardboard container to cardboard object. Carl was aware of Woodrow and Tony Cragg in the early 1980s and his appreciation for their work from this period remains undiminished. Carl particularly admires Cragg's arrangements of multi-coloured plastic on the floor, the "slightly topographical collections of disks and odds and ends" and the floor pieces where the artist "would spiral up from things on the ground. When I was putting those cardboard things in the trash that work was very much on my mind." He also retains his admiration for Woodrow's *Twin Tub with Guitar* (1981), a washing machine which was cannibalized to fabricate a guitar. What Jean-Christophe Ammann said about Woodrow, that "he is a sculptor and he concentrates entirely on his material," could be said equally about James Carl.

When Carl shifted away from cardboard pieces and moved towards carving in marble and jade in 1994, it was because he felt had exhausted the possibilities of the medium. "I was at the tail end of what I wanted to do with cardboard. I simply wanted to see what would happen with the opposite end of the material spectrum." The work that emerged was *takeouts,* a series of Styrofoam hamburger and sauce containers, and coffee cups, carefully carved from white marble. These remarkable works were made in Beijing and Toronto and they are part of an ongoing body of work. They measure Carl's wit: concentrating on the castoffs of consumer culture, he made dumpsters and large domestic appliances out of cardboard and subsequently threw them away; following that, he has taken the idea of disposability and carved what would be throwaway containers out of precious material.

Carl is a consummate trickster. His applied engagement with the complications of truth-to-materiality is more an affirmation than an abdication of the visual. In this understanding, phenomenology and its perceptual engine does not so much undermine any epistemological recognition generated by the work as it encourages the same objectives and results: to make things, objects that invite a range of meanings. Invariably, Carl returns to the notion of the "what" as the catalyst for a range of thinking that, while it includes speculation and doubt, does so in the determining shadow of the phenomenon, the sculptural "what." As the artist says, "One of the things that has frequently been overlooked is that a great portion of my decision-making process is visual. I was educated in arguments that questioned the primacy of visuality, and I understand, in my own way, the history of 20th century art and the undermining of the visual.... I've never really been afraid of the visual. I go with the disciplinary attribute. I'm a visual artist."

Notes

[1] Robin Peck, "Rock, Paper, Scissors: the Sculpture of James Carl," in *Plot*, cat. (Vancouver: Contemporary Art Gallery/Open Space, 2003), p. 9.

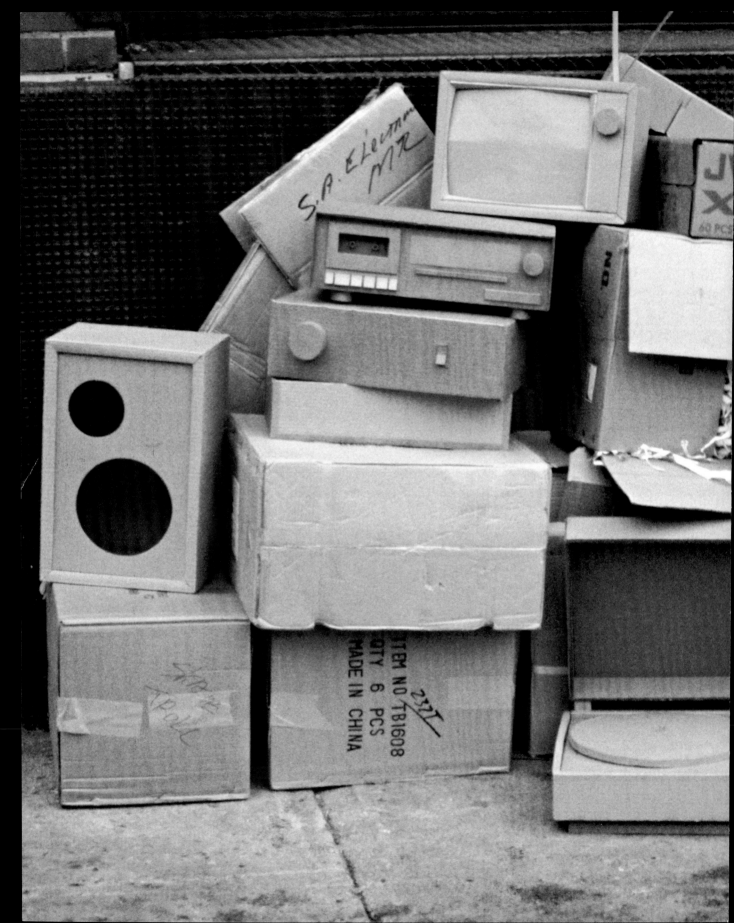

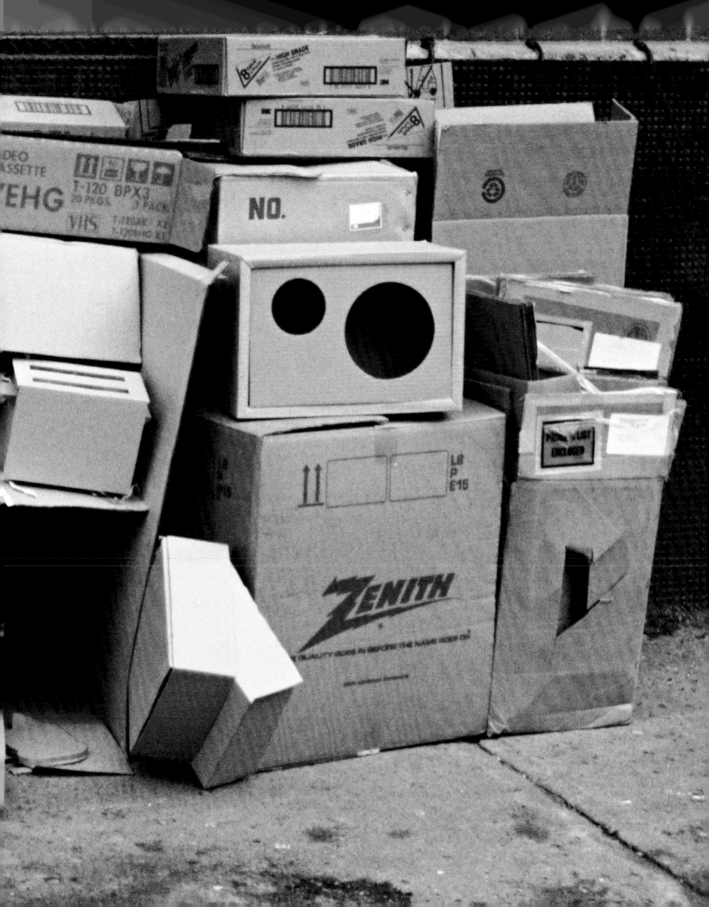

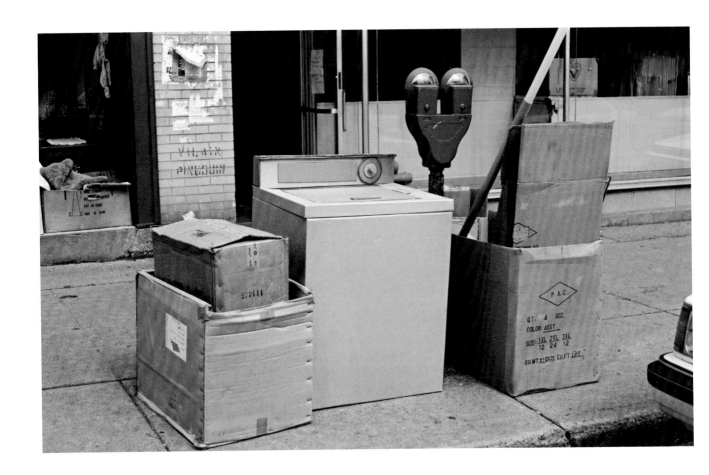

re:possession 1990–1994

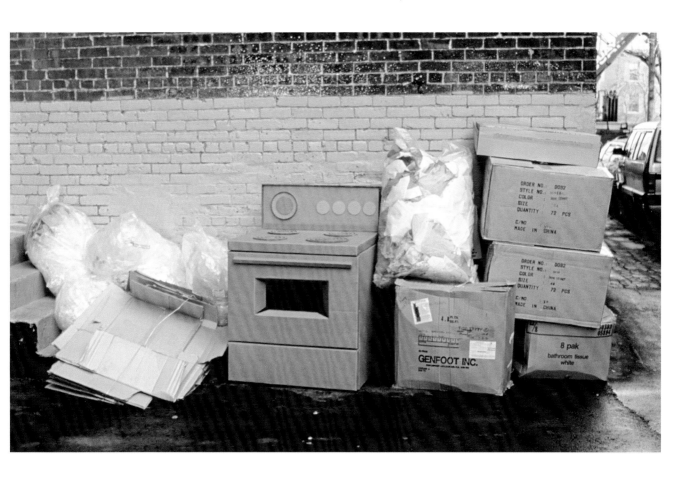

re:possession 1990–1994

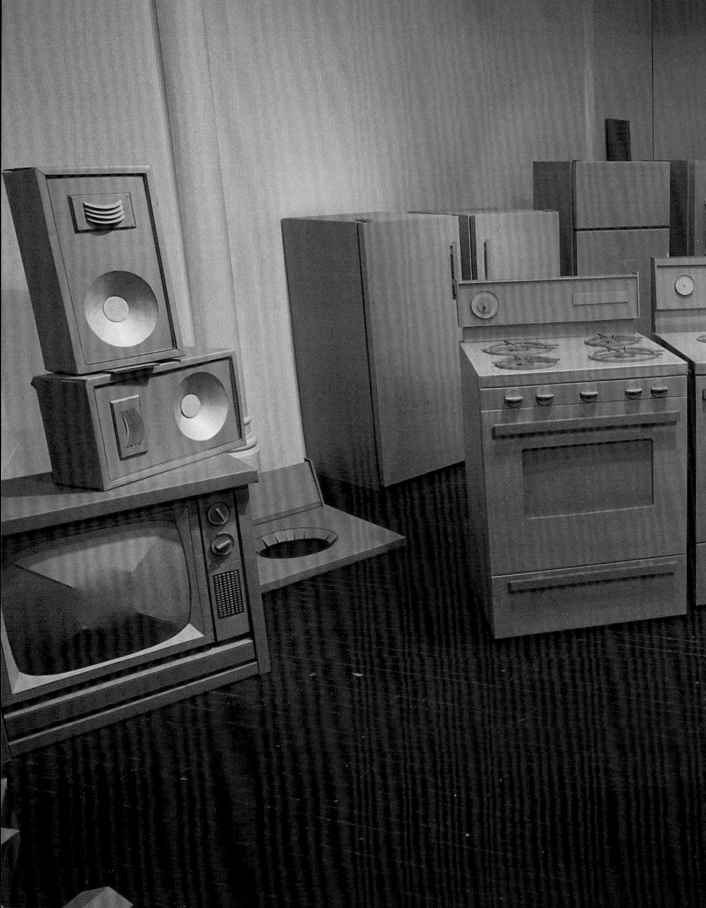

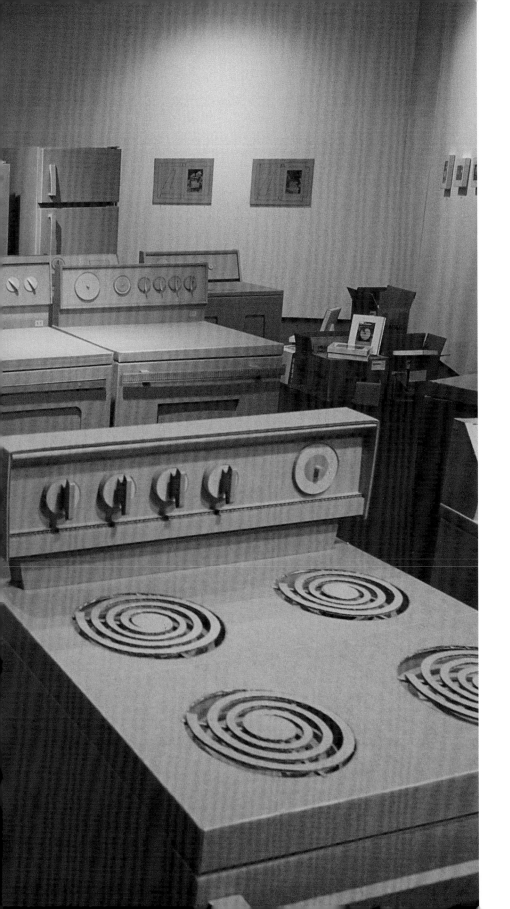

re:possession 1990–1994

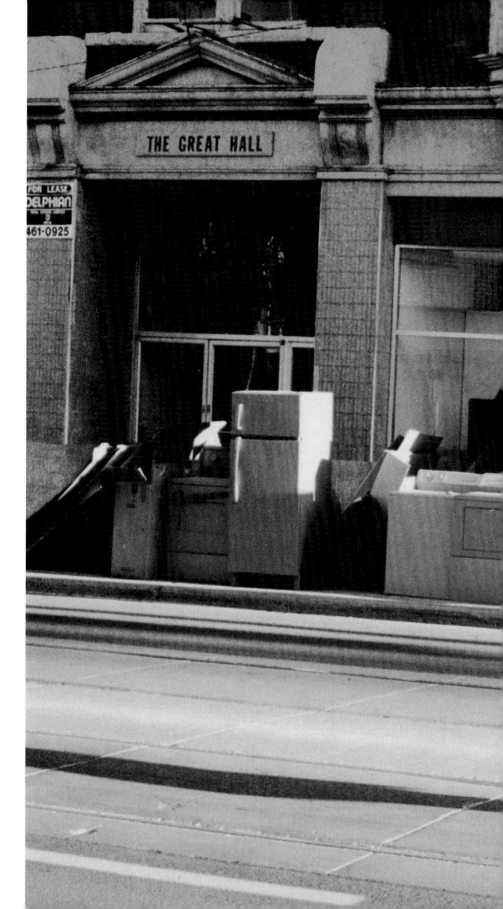

re:possession 1990–1994

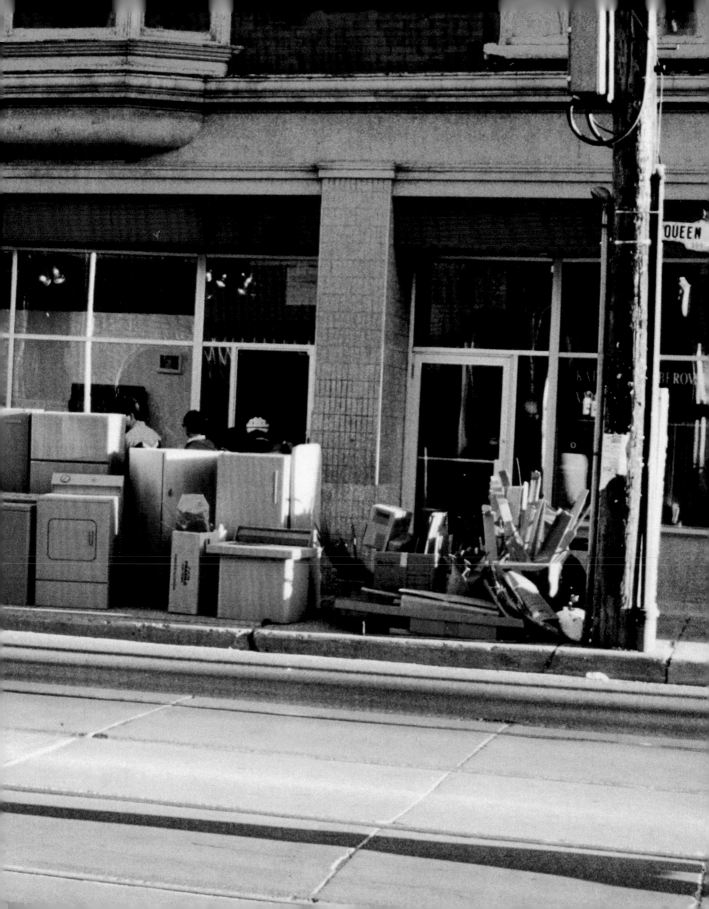

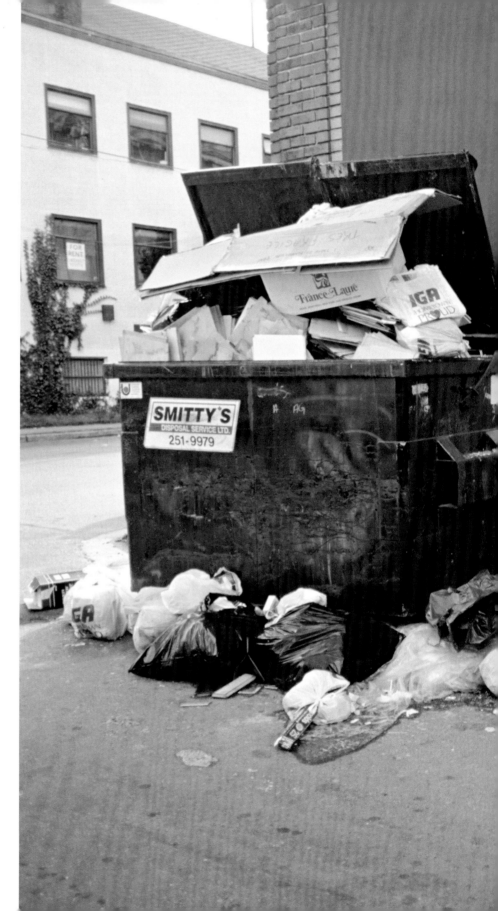

public works: cardboard only 1993

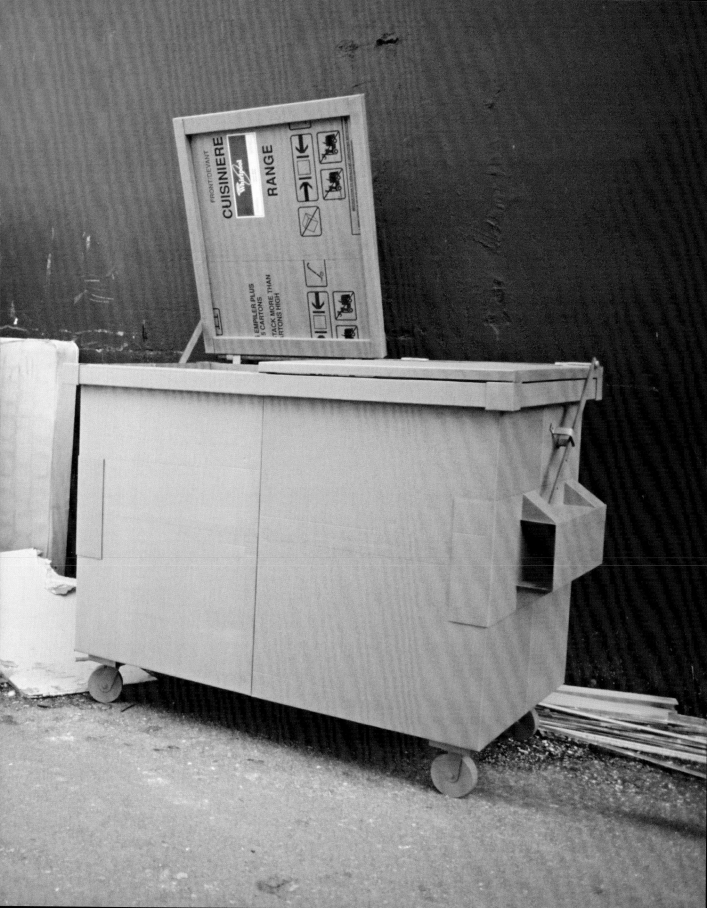

public works: cardboard only 1993

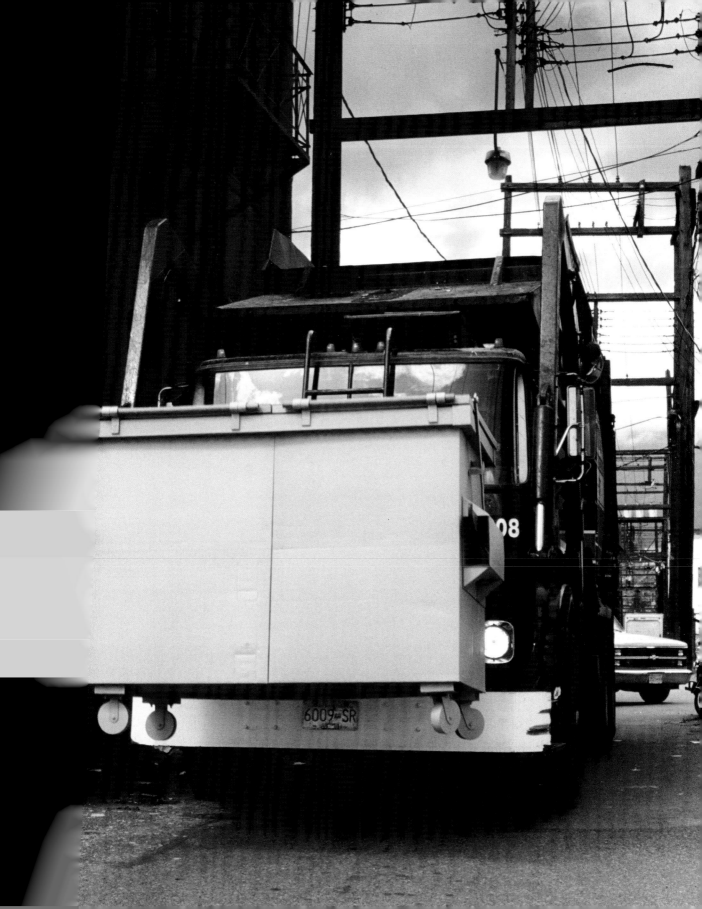

relief 1997

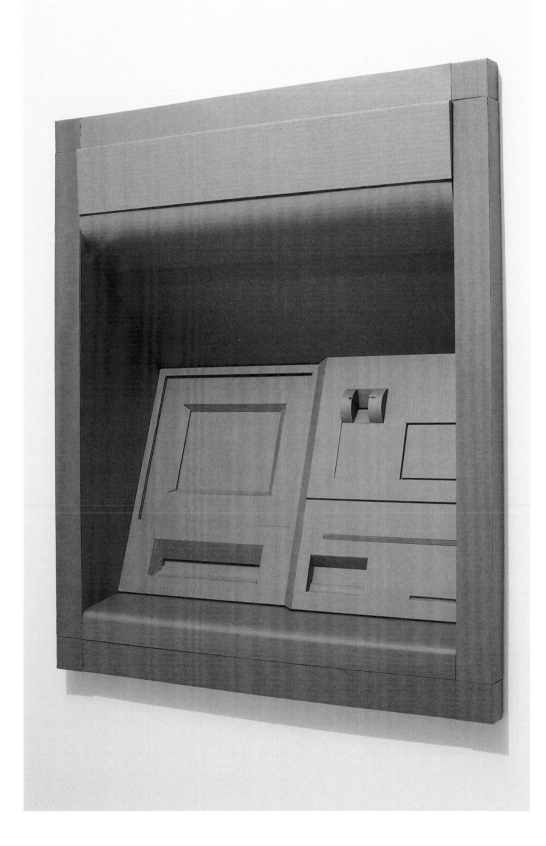

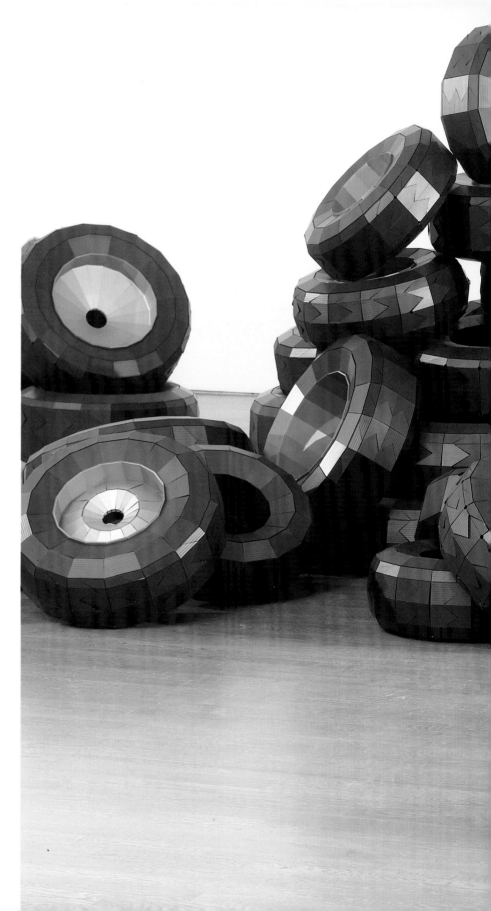

white walls 1998-ongoing

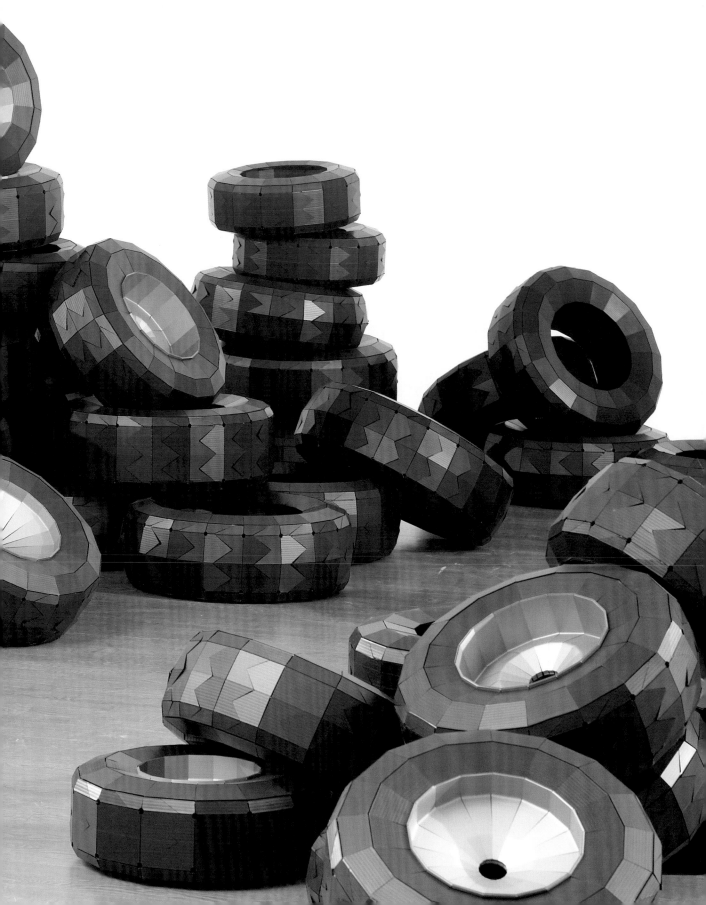

plot 2003

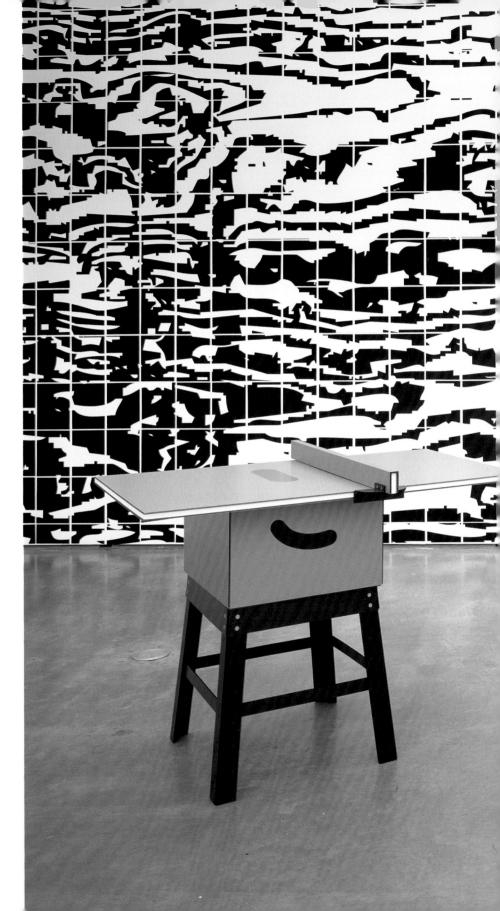

plot 2003

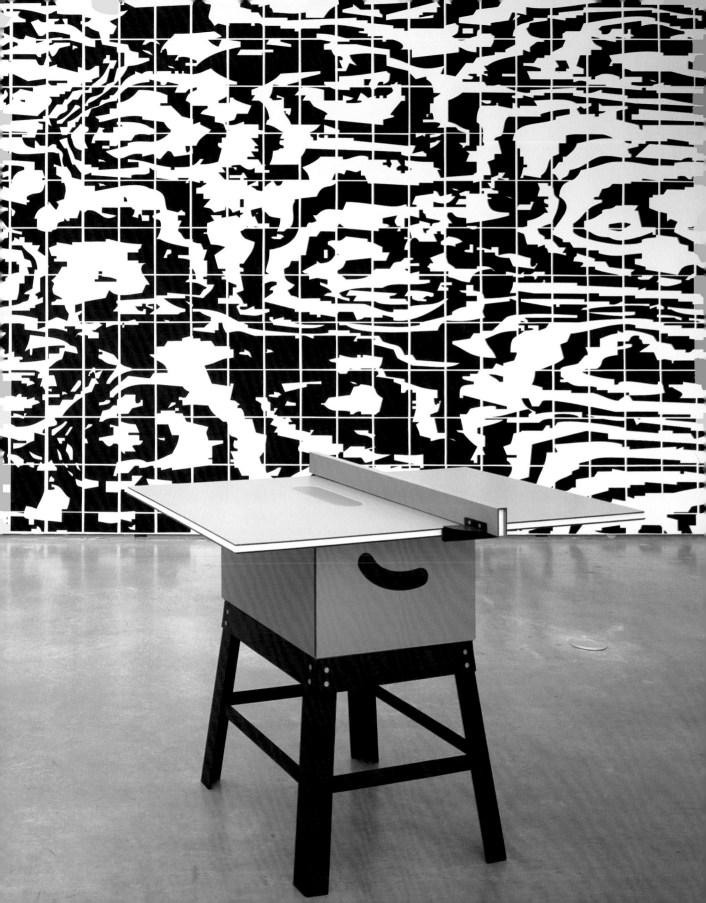

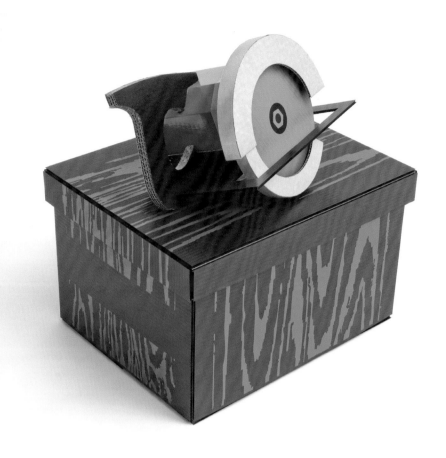

skil 2003

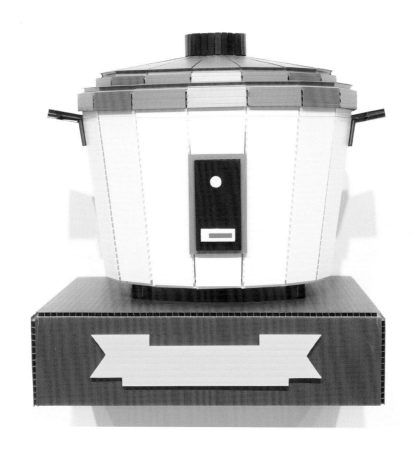

dynasty 2000

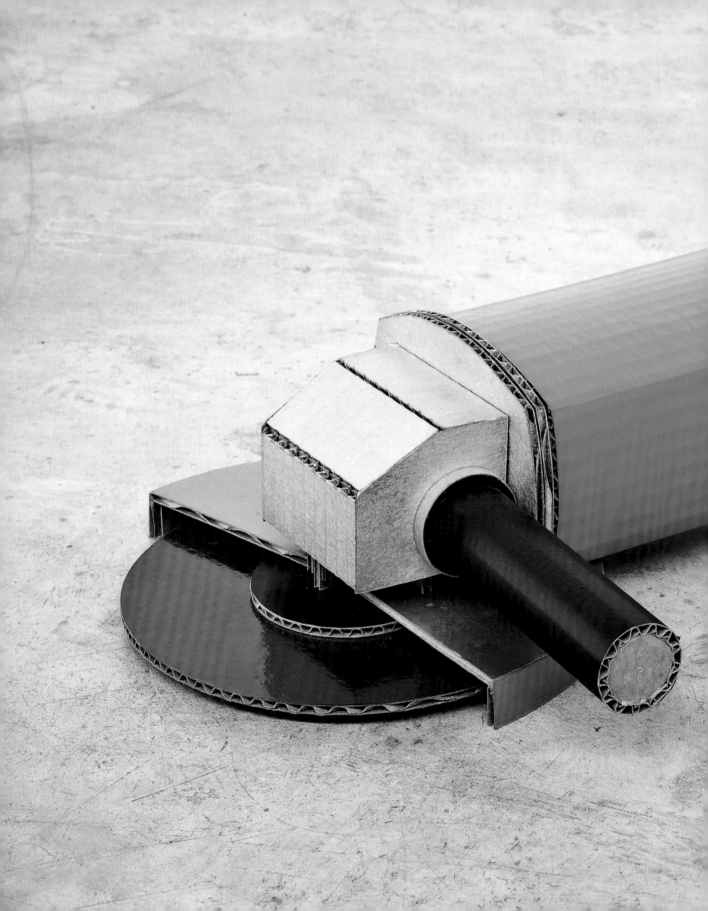

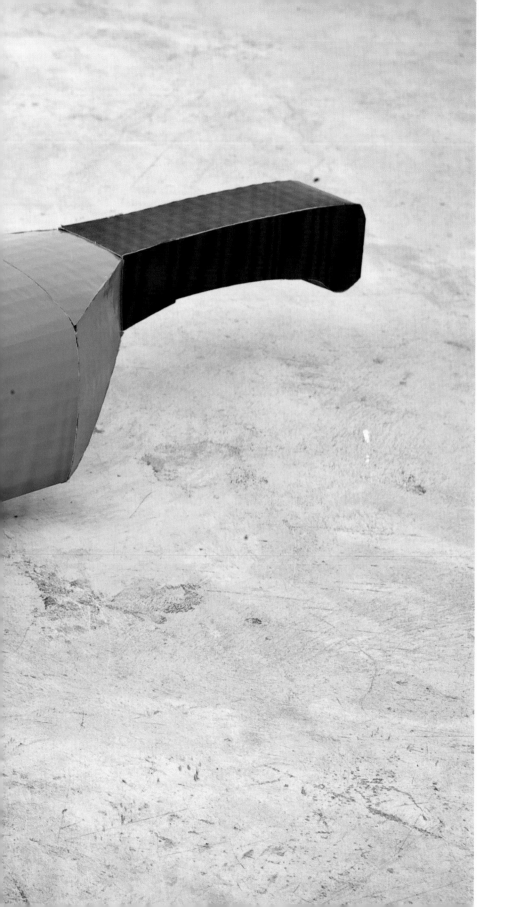

r-bite (grinder) 2003

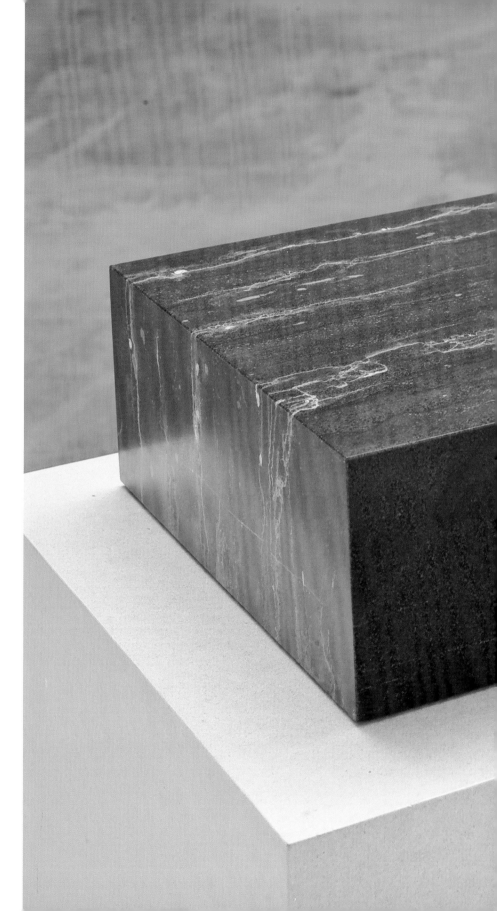

deck 1995

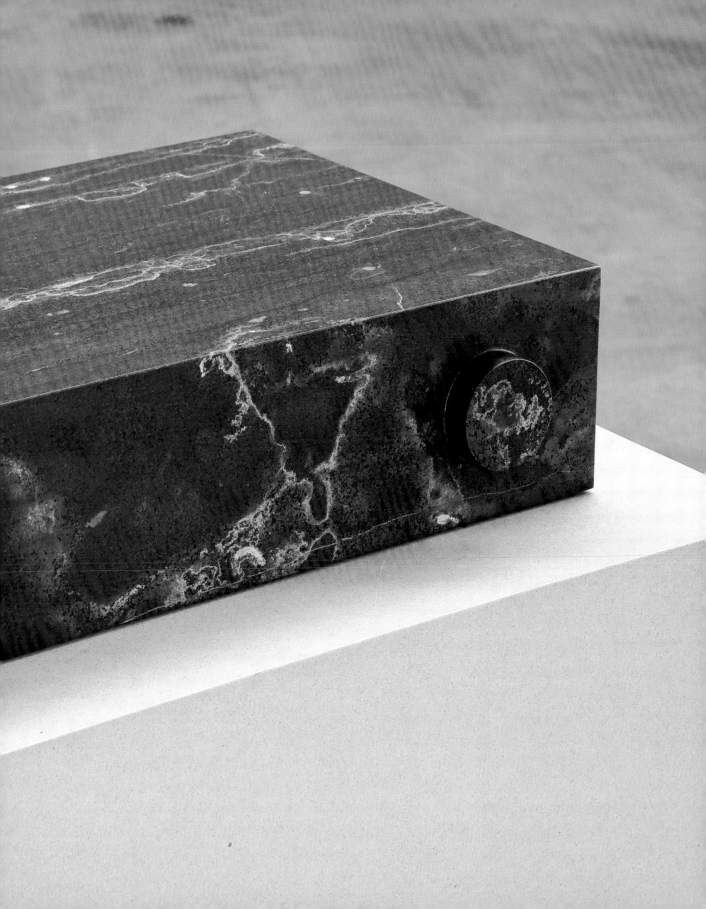

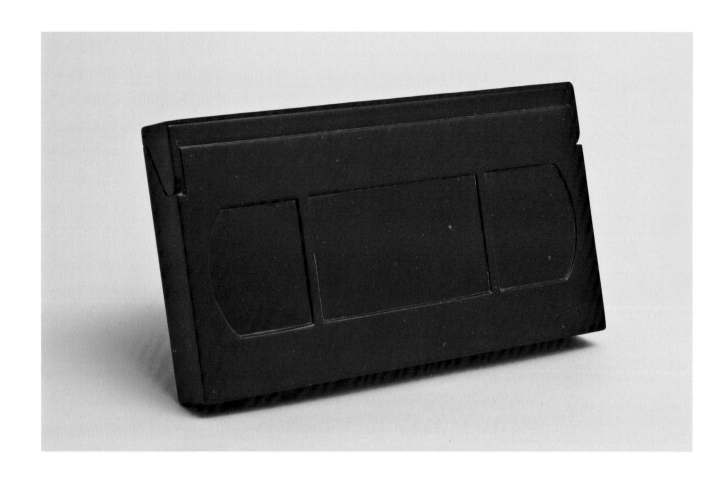

empty orchestra 1995–2000

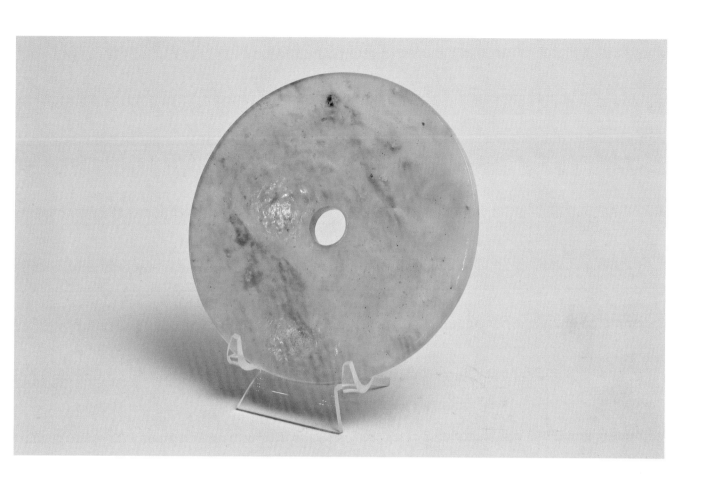

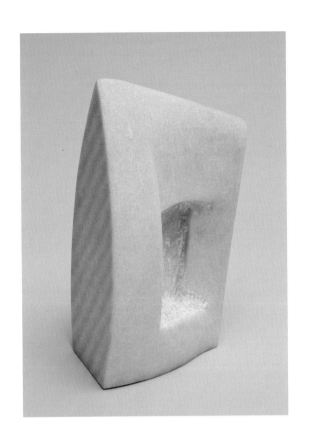

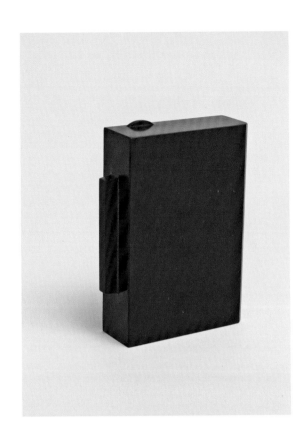

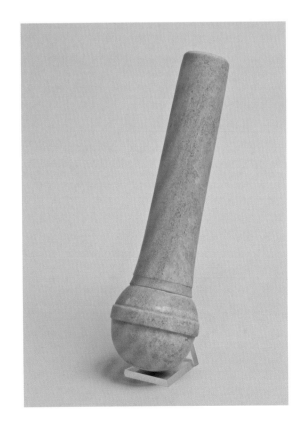

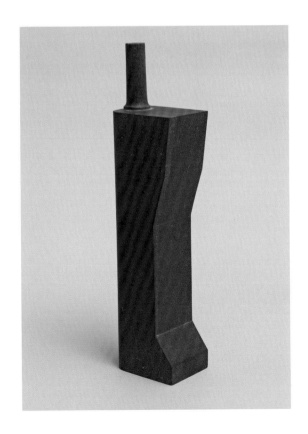

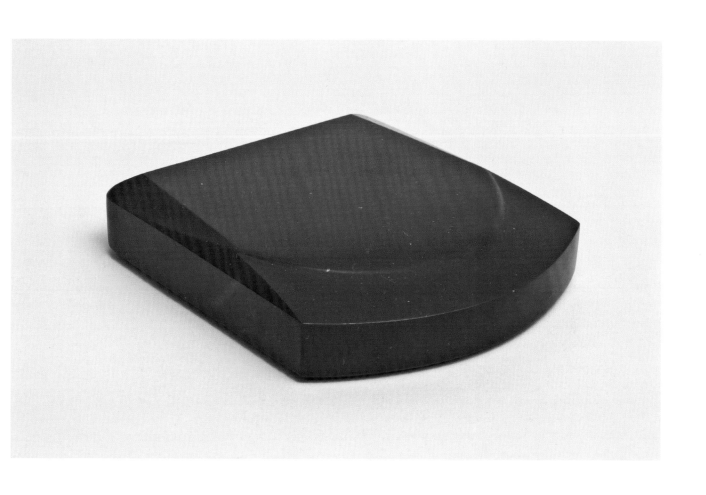

empty orchestra 1995–2000

takeouts 1995–ongoing

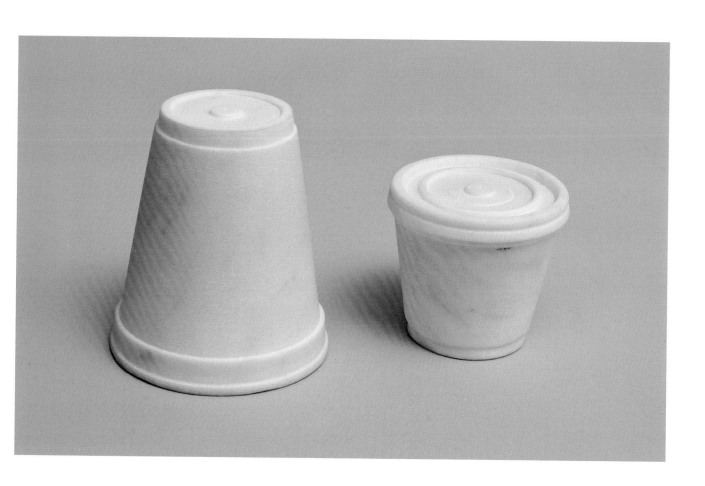

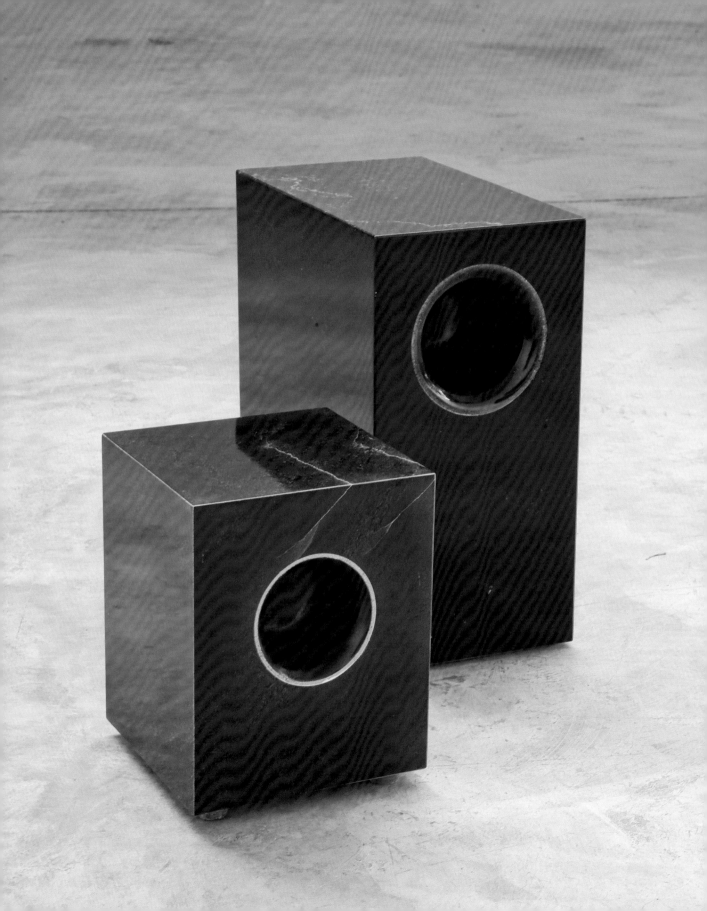

woof 2006

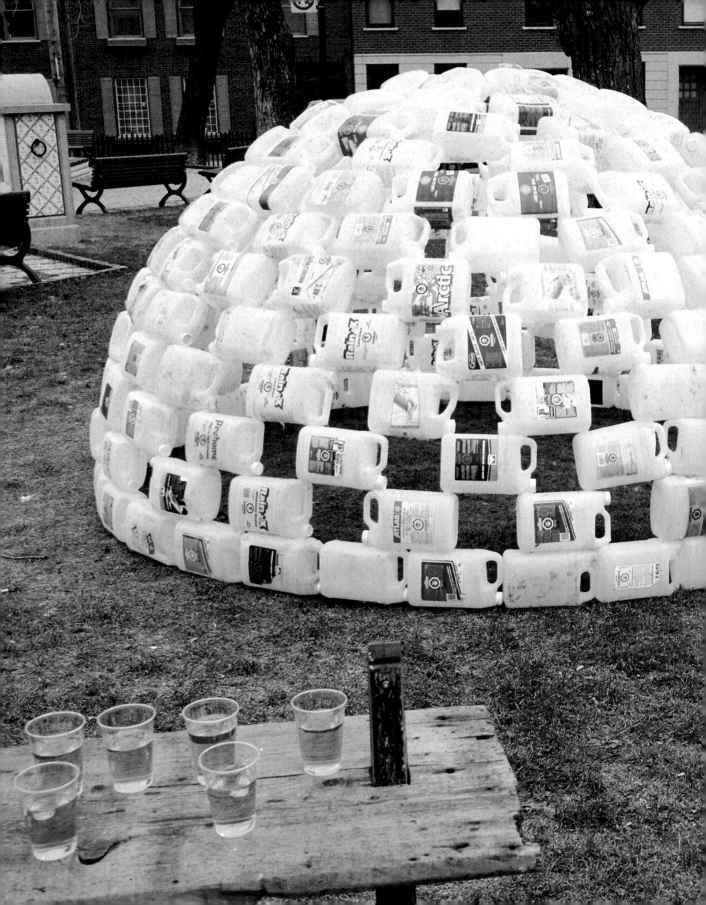

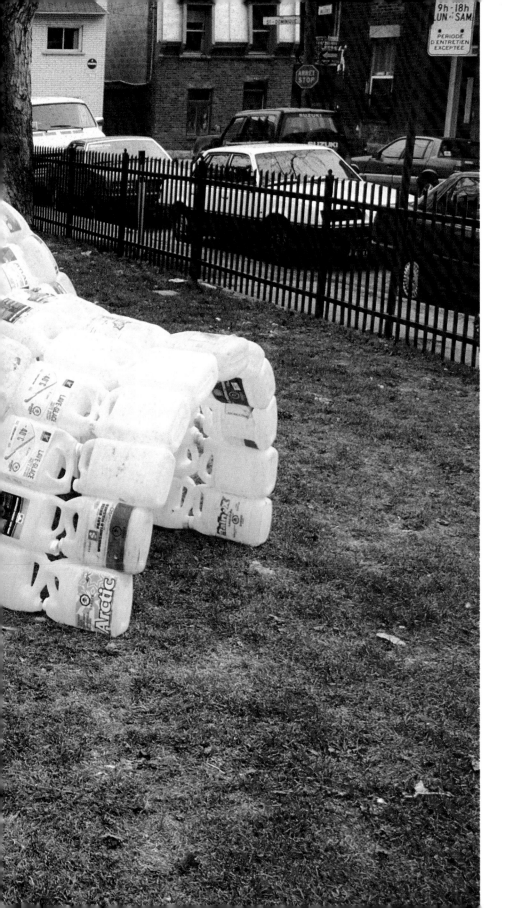

spring collection 1991

redemption 1993

escalation 1994

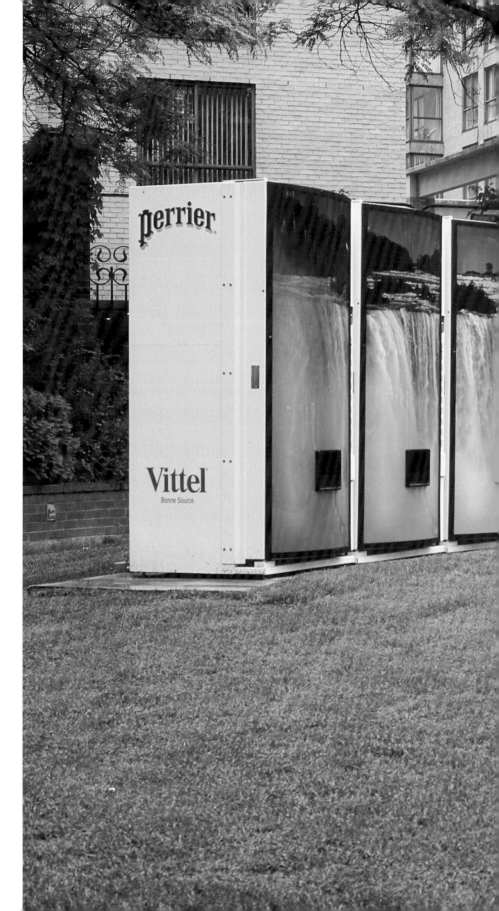

fountain 1997

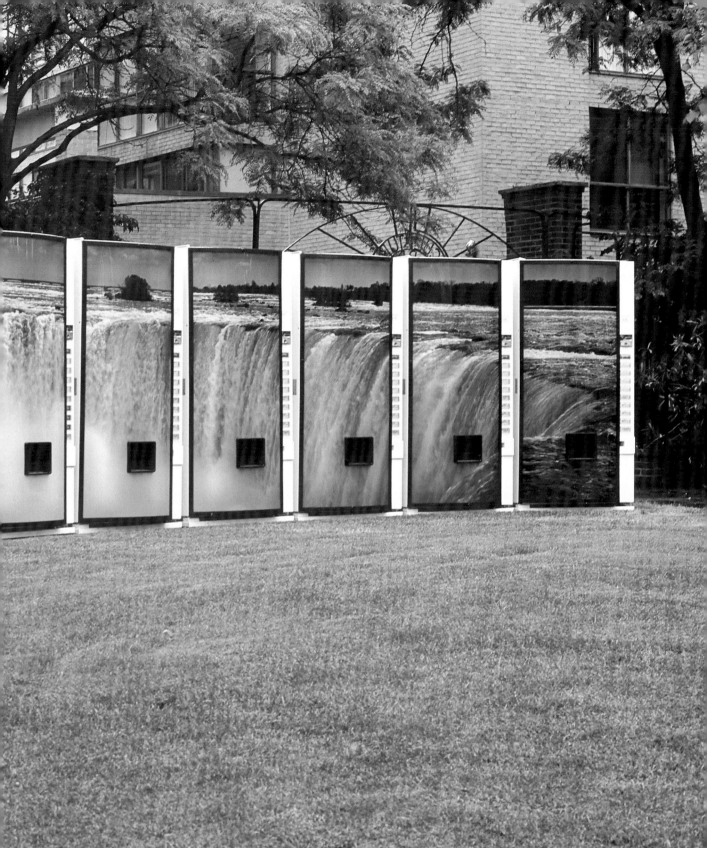

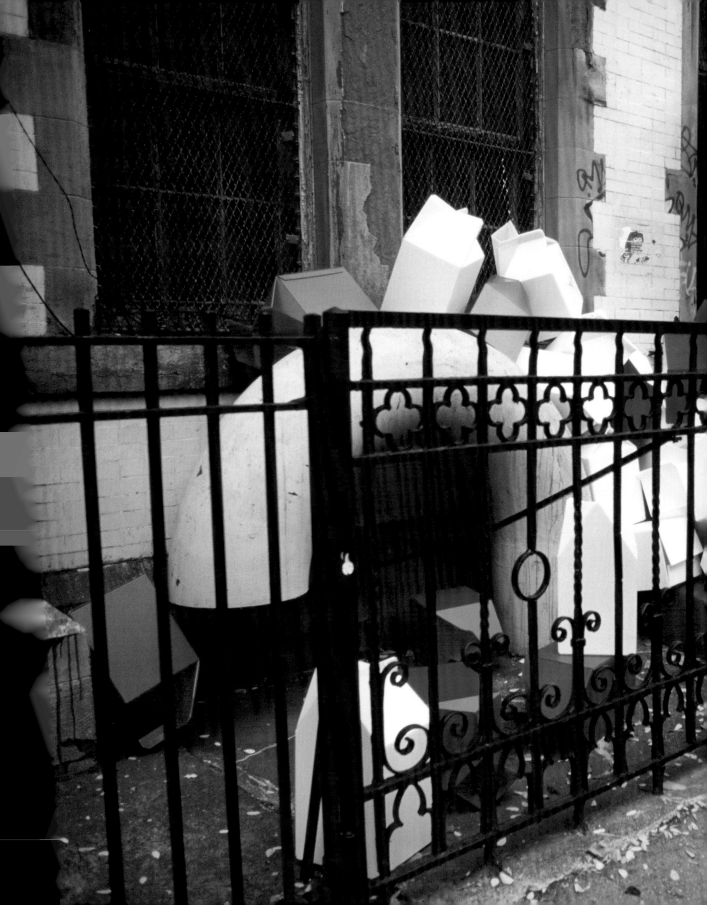

2% 1997

concession 2002

osmosis 2004

proposed monument for a clover leaf 2002

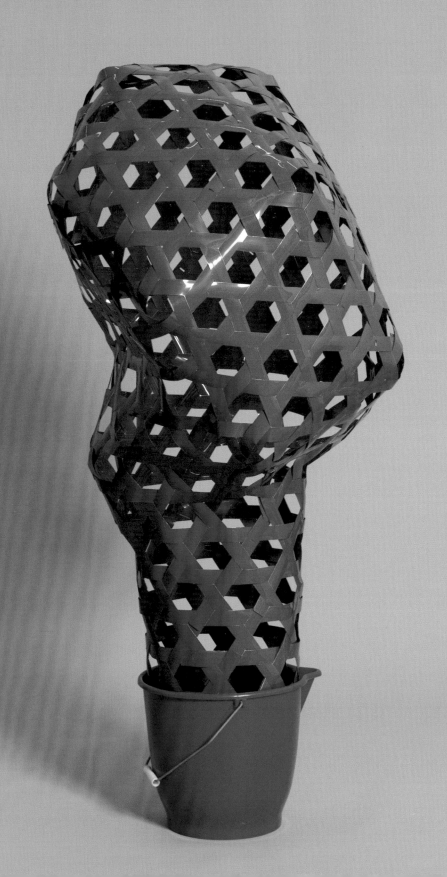

jalousie #1 2006

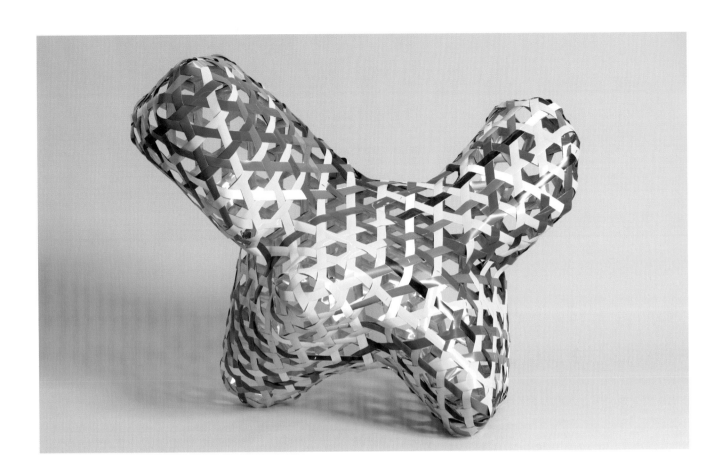

jalousie (the space between letters on a page) 2007

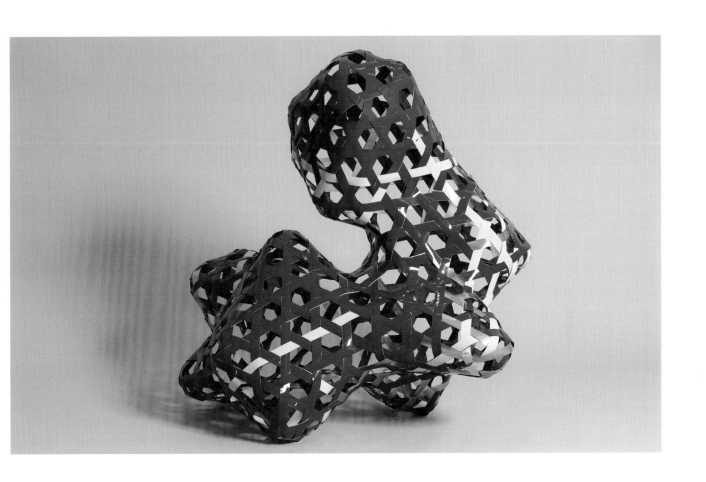

jalousie (the space around shadows) 2007

jalousie (envy) 2007

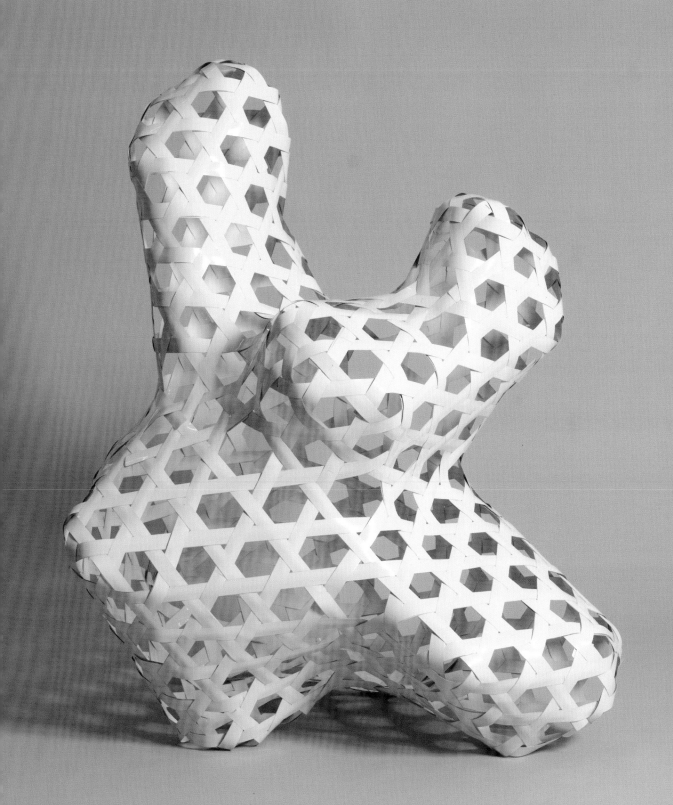

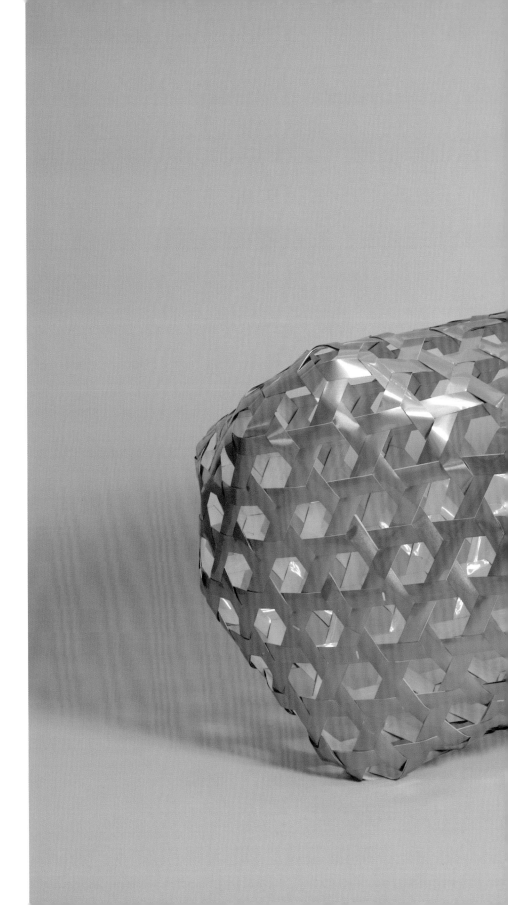

jalousie (slug) 2007

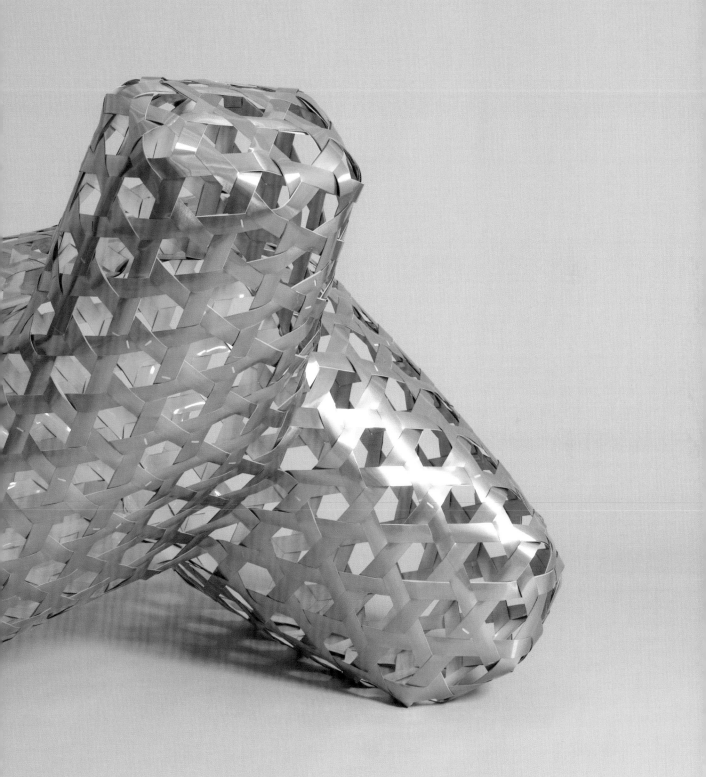

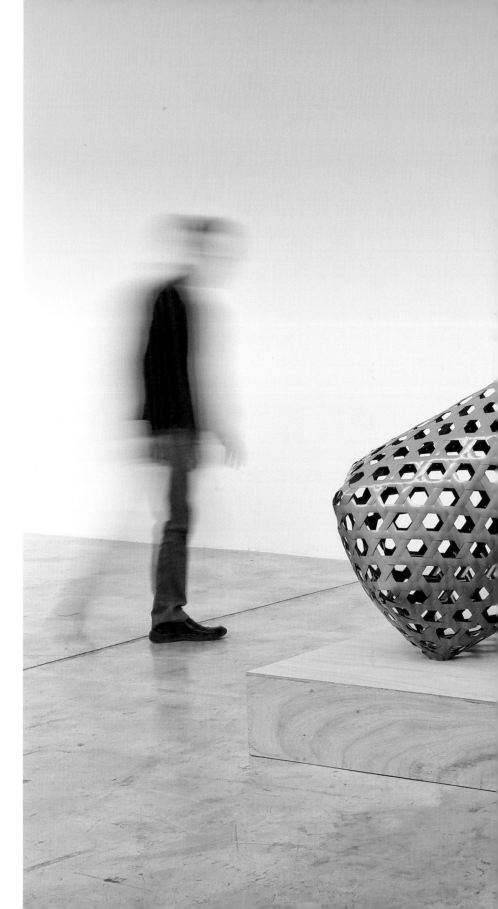

jalousie (baluster) 2008

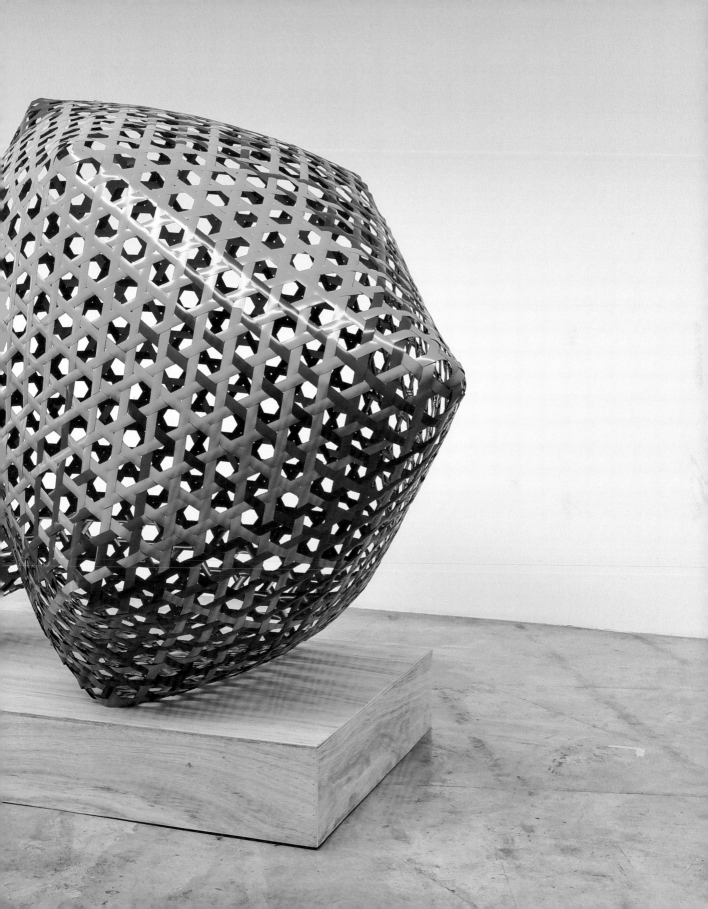

jalousie (baluster) 2008

jalousie (roman) 2008

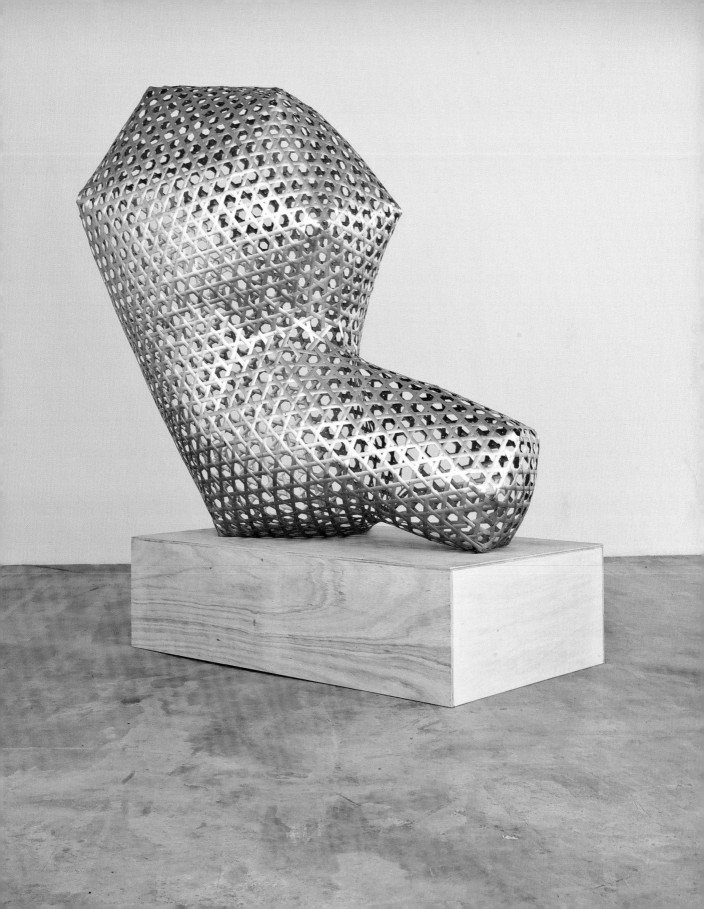

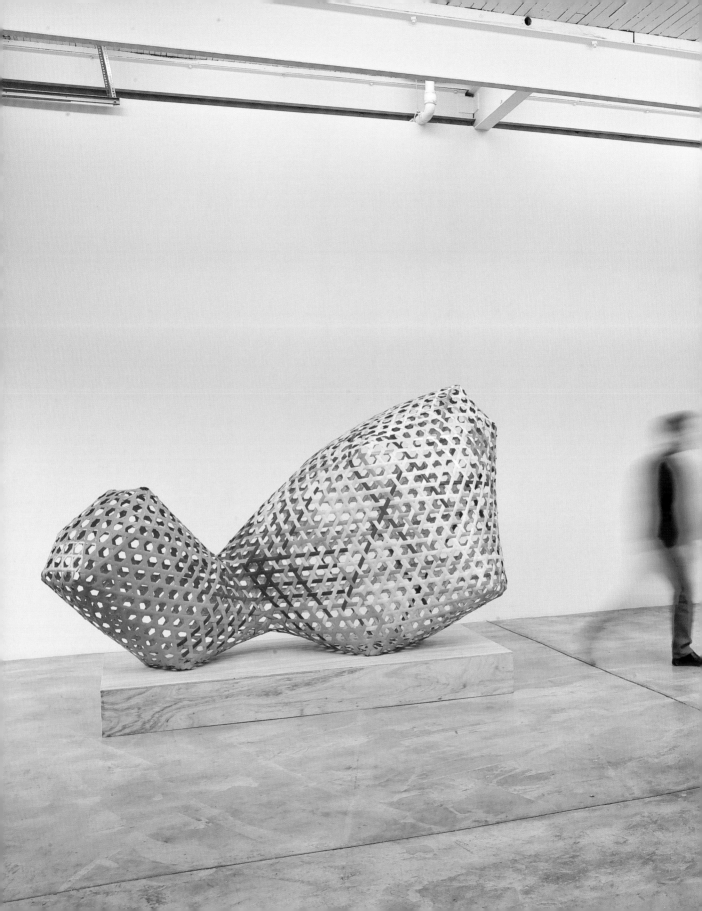

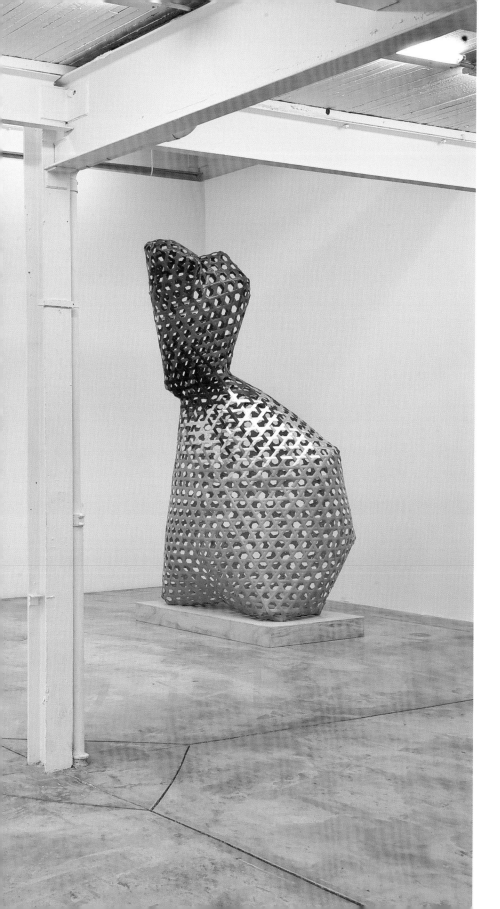

jalousie 2008

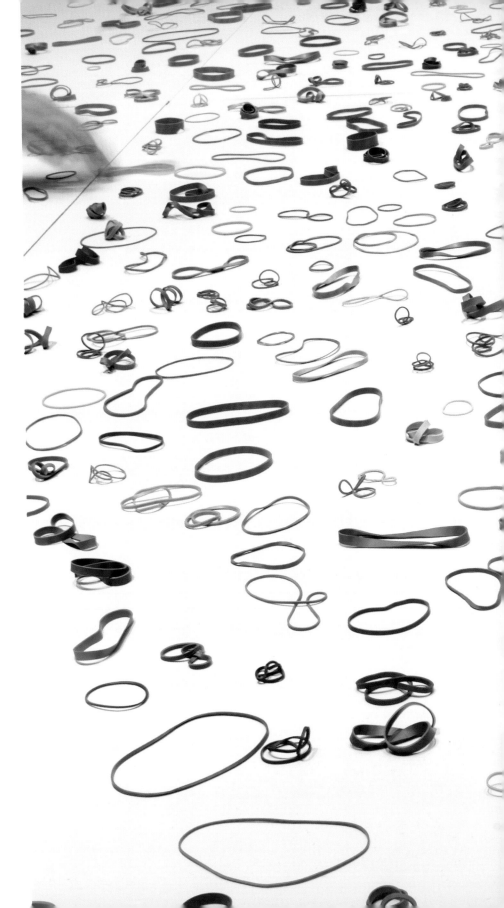

thing's end 2008

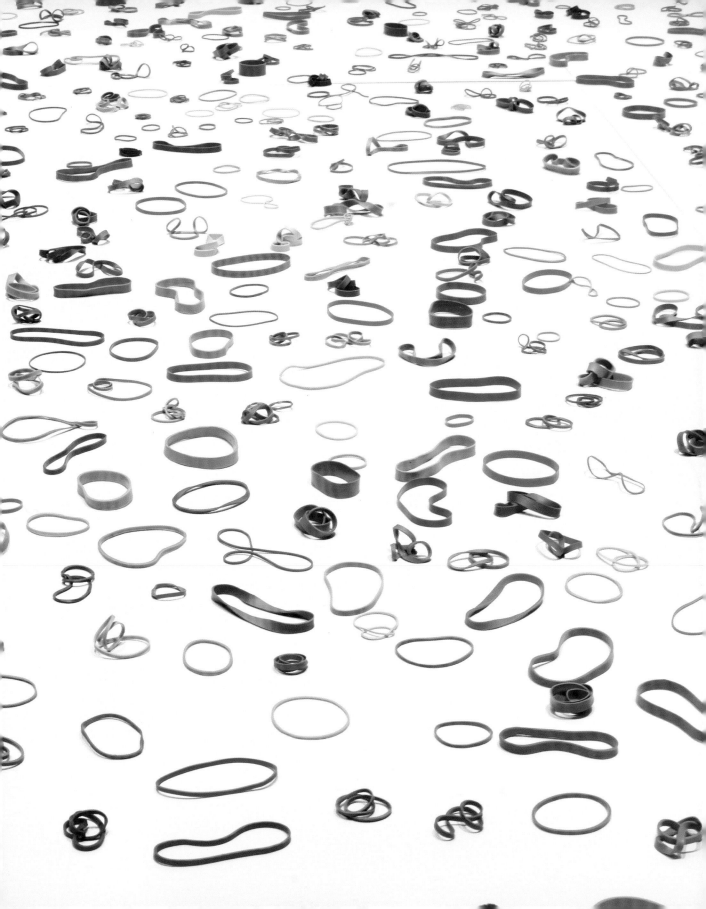

do you know what 2008–2009

Justina M. Barnicke Gallery

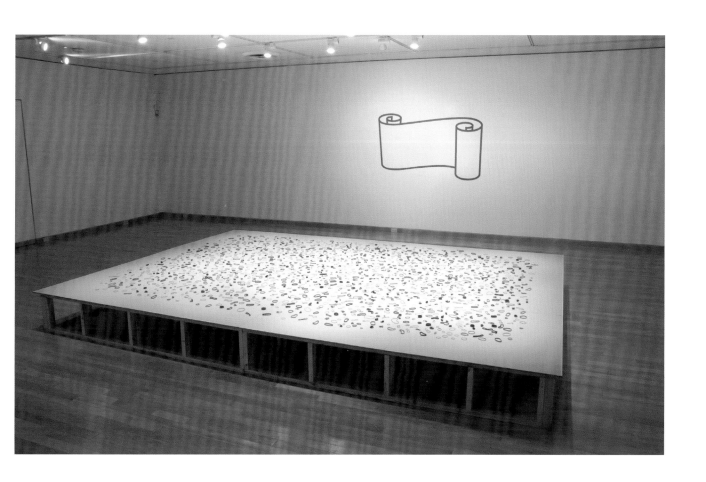

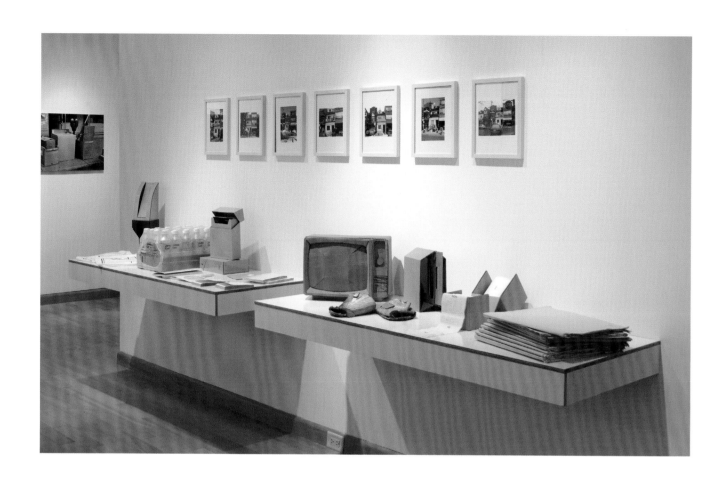

do you know what 2008–2009

Justina M. Barnicke Gallery

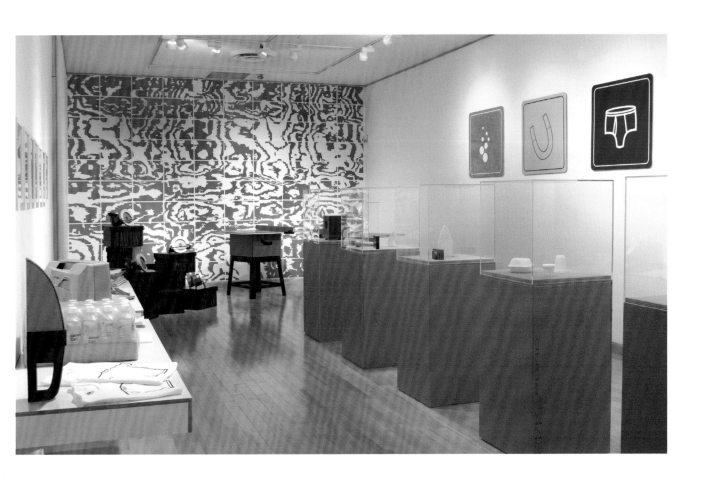

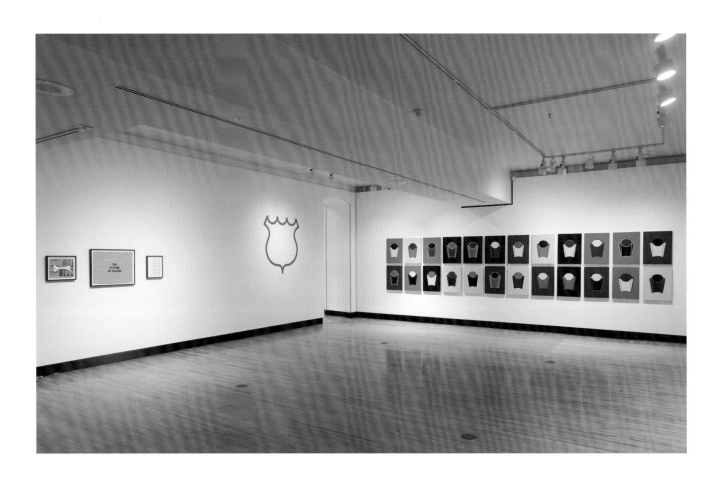

do you know what 2009

Macdonald Stewart Art Centre

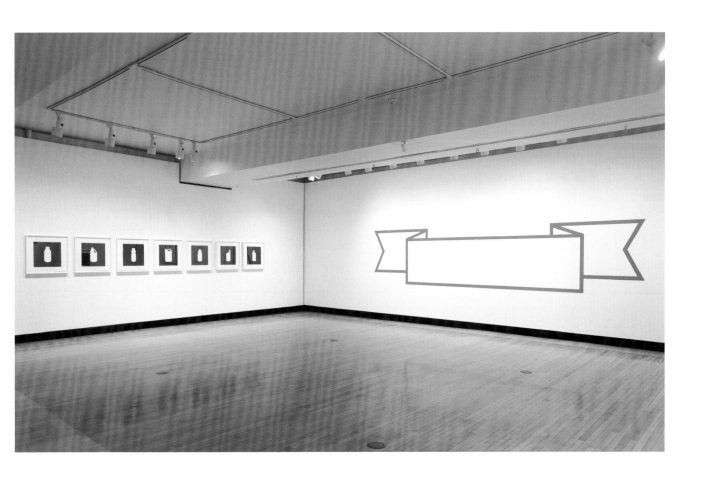

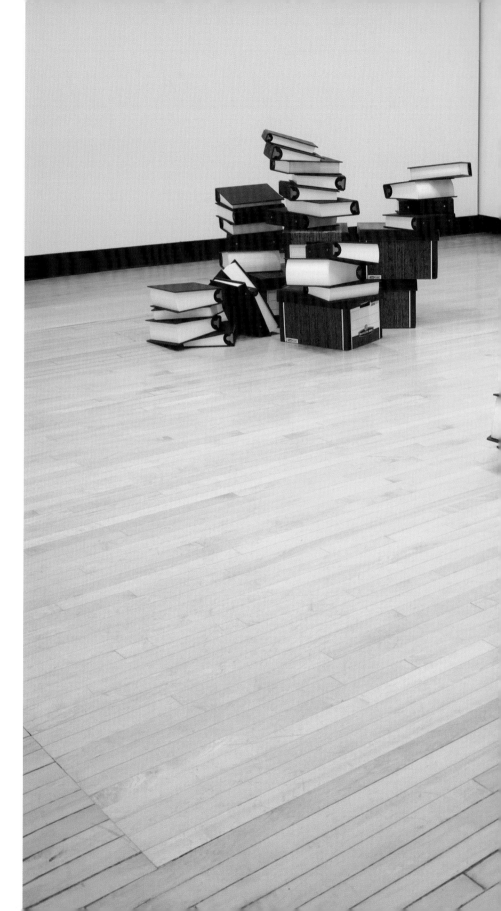

do you know what 2009

Macdonald Stewart Art Centre

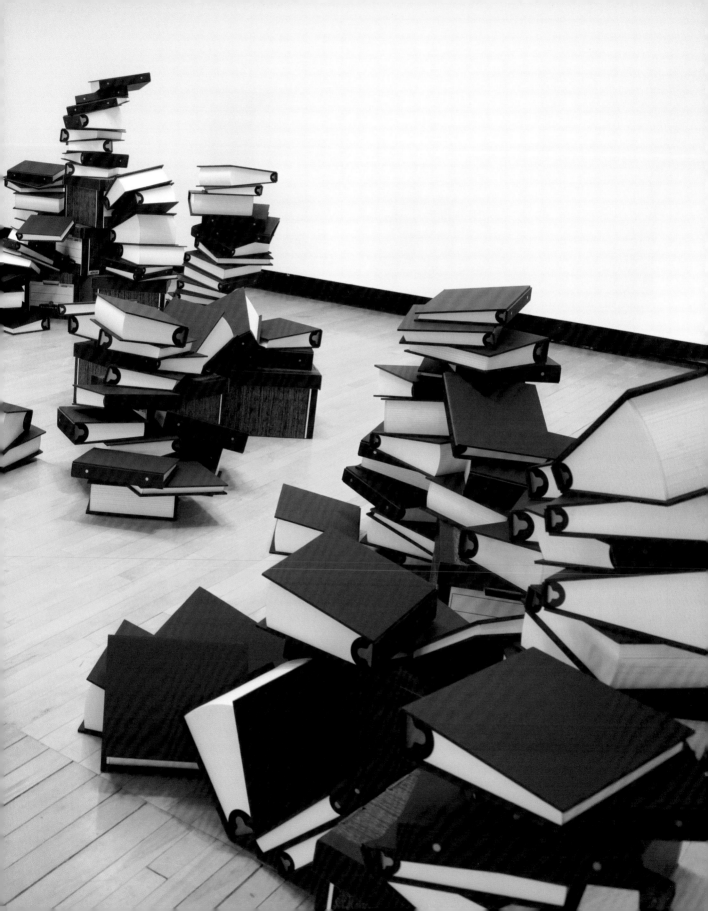

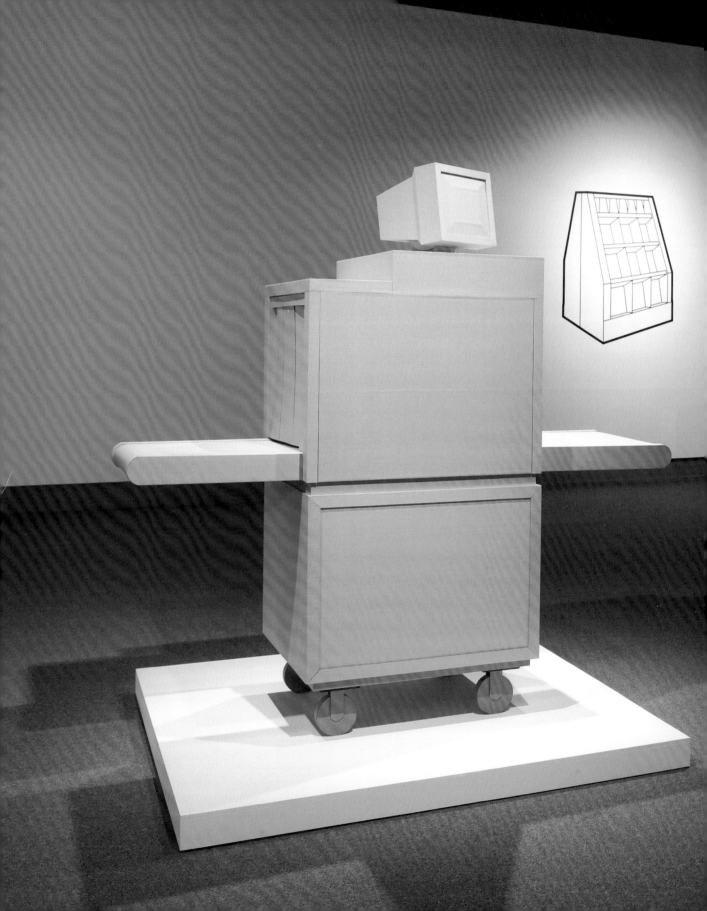

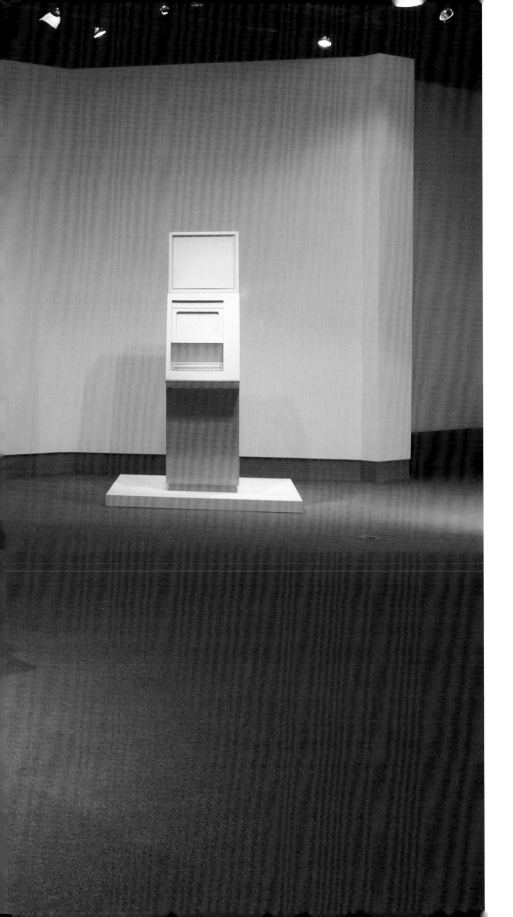

do you know what 2009

Cambridge Galleries

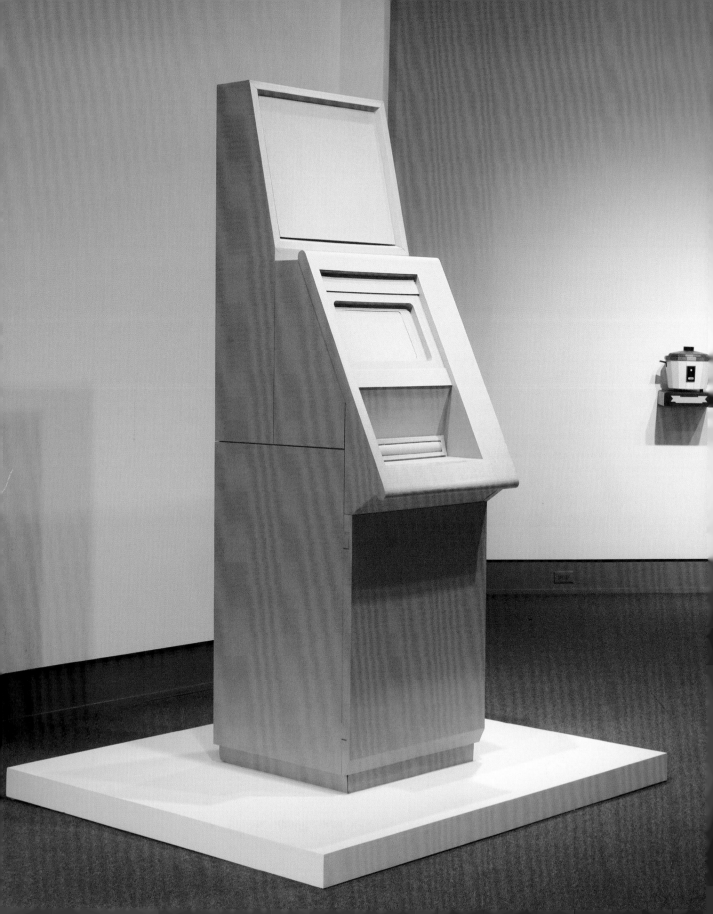

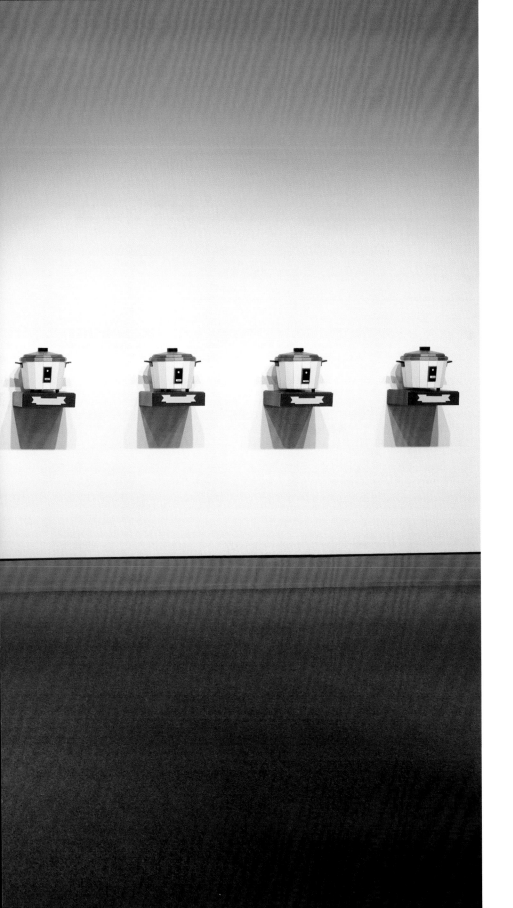

do you know what 2009

Cambridge Galleries

do you know what 2009

Cambridge Galleries

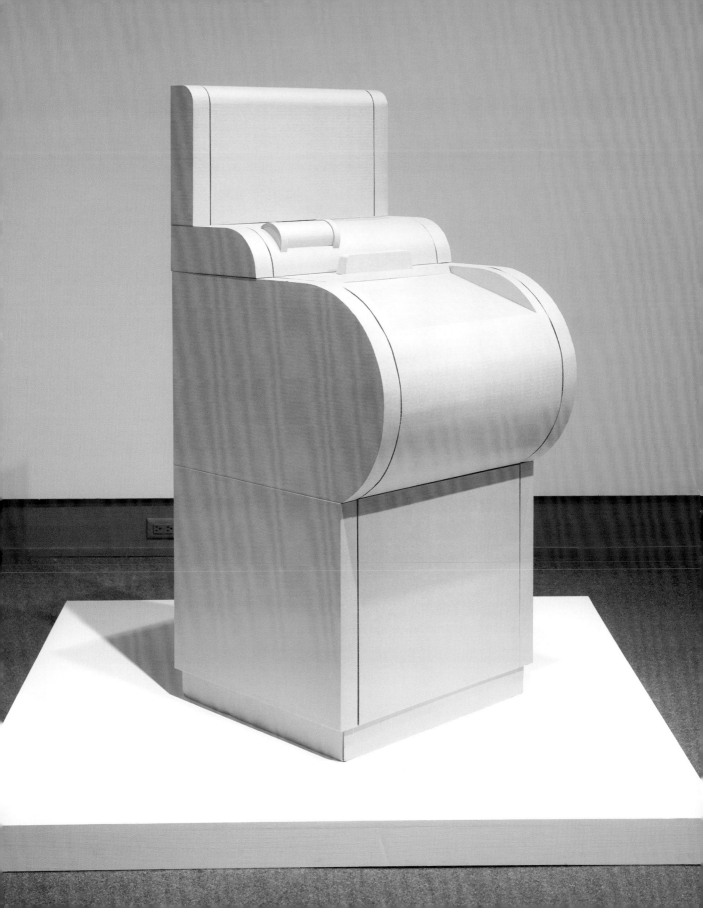

James Carl

EDUCATION

1996	Rutgers University, New Jersey	MFA
1992	McGill University, Montreal	BA Honours
1990 & 1995	Central Academy of Fine Art, Beijing	Diplomas
1983	University of Victoria, British Columbia	BFA Honours

SELECTED SOLO EXHIBITIONS

2008	*jalousie*, Diaz Contemporary, Toronto
2007	*jalousie*, Heinz Martin Weigand, Karlsruhe, Germany
2006	*negative spaces*, Florence Loewy, Paris, France
2003	*plot*, Contemporary Art Gallery, Vancouver
2002	*bottom feeder*, Mercer Union, Toronto
1999	*work*, Galerie Haus Schneider, Karlsruhe, Germany
1998	Galerie Clark, Montreal
	stock, Art Metropole, Toronto
1997	*fountain*, Toronto Sculpture Garden, Toronto
1994	*unentitled*, YYZ Artists' Outlet, Toronto
1993	*public works*, Grunt Gallery, Vancouver
1992	*re:possession*, Galerie Clark, Montreal

SELECTED GROUP EXHIBITIONS

2008	*All Together Now: Recent Toronto Art*, Art Gallery of Ontario
	Arena, Art Gallery of Nova Scotia, Halifax
	ABC with Love, Art Metropole, Toronto
2007	Diaz Contemporary, Toronto
	Funhouse, Art Gallery of Alberta
2006	*Habitat*, Jessica Bradley Art + Projects, Toronto
2005	Diaz Contemporary, Toronto
2004	*Le Lieu en Practique*, Artexte, Montreal
	Constructa, Galerie 5020, Salzburg, Austria
	Constructive Folly, Doris McCarthy Gallery, University of Toronto
2003	*Re:cycle*, McMaster University, Hamilton
2002	*New Modular*, Blackwood Gallery, University of Toronto
	Provisional Worlds, Art Gallery of Ontario, Toronto
	Don, Chinati Foundation, Marfa, TX
	Pile, Barkenhoff Atelier, Worpswede, Germany
2001	*Promises*, Contemporary Art Gallery, Vancouver
	Forever, Embassy of Canada, Beijing
	First Light, Bellevue Art Museum, WA
	Objets de Convoitise, Galerie 101, Ottawa

2000	*Minimal Pop*, Traywick Gallery, Berkeley, CA
	Minutia, Southeastern Center for Contemporary Art, Winston-Salem, NC
	Climbing the Walls, Robert Birch Gallery, Toronto
1999	*New Urban Sculpture*, New York Public Art Fund at MetroTech Center, Brooklyn, NY
	Spatial Interest, Workspace, New York, NY
	Summit, Galerie 5020, Salzburg, Austria
1999	*Something*, Kunstverein Hannover, Germany
	I'm the Boss of Myself, Sara Meltzer, New York, NY
1997	*Wrong Place, Right Time*, Double Pleasure, New York, NY
	Mannequins, Villa Minimo, Hannover, Germany
	Face Value, PS 122, New York, NY

SELECTED CRITICAL REVIEWS

Terrence Dick, "What You See is What You Don't Get..." *Border Crossings*, v. 28 no. 2, May 2009, pp. 56-65.

Pamela Meredith, "James Carl," *Canadian Art*, v. 26 no. 2, Summer 2009, p. 103.

Dan Adler, "James Carl: Diaz Contemporary," *Artforum International*, v. 47 no. 6, February 2009, p. 202.

Sarah Milroy, "Getting under the skin of things," *Globe and Mail*, 10 Jan. 2009, p. R6.

Robin Peck, "Rock Paper Scissors," *C Magazine*, no. 84, Winter 2004, pp. 30-33.

Sarah Milroy, "Conceptual Art with your Pradas?" *Globe and Mail*, 4 Feb. 2004, p. A3.

Betty Ann Jordan, "Message in a Bottle," *Toronto Life*, v. 36 no. 16, October 2002, p. 54.

Rosemary Heather, "Private Public Art Venues and the Untamed Audience" *C Magazine*, no. 75, Fall 2002, pp. 28-30.

Sarah Milroy, "Thoroughly Modern Art," *Globe and Mail*, 25 Sept. 2002, p. R5.

Ann Dean, "Politics and Romance in James Carl's Redemption," *C Magazine*, no. 73, Spring 2002, pp. 22–23.

Michael Scott, "Gallery lives up to Promises," *Vancouver Sun*, 15 Nov. 2001, p. C4.

Gillian MacKay, "Mother Knows Best," *Globe and Mail*, 3 Nov. 2001, p. V5.

Ruth Dusseault, "Winston-Salem," *Art Papers*, v. 25, no. 3, May/June 2001, pp. 40-41.

Jill Conner, "Bellevue, Washington," *Art Papers*, v. 25 no. 3, May/June 2001, p. 55.

Aline Bégin, "Où Convoitise et commerce se rencontrent," *Le Droit*, 21 Apr. 2001, p. A46.

Ron Glowen, "Luminous at the Bellevue Art Museum," *Artweek*, v. 32 no. 3, March 2001, pp. 22–23.

Jessica Bradley, "On James Carl and Building a Public Collection," *Canadian Art*, v. 18 no. 4, Winter 2001, pp. 70-75.

Daphne Gordon, "Art by Numbers," *Toronto Star*, 10 Feb. 2001, p. M10.

Doug Kim, "Museum premiers with light, passion," *Seattle Times*, 7 Jan. 2001, p. F1.

Robert Mahoney, "New Urban Sculpture," *Time Out New York*, 31 Oct. 2000, p. 56.

Roberta Smith, "Stretching Definitions of Outdoor Sculpture," *New York Times*, 28 Jul. 2000, p. B25.

Glen Helfand, "Minimal Pop," *San Francisco Bay Guardian*, 3 May 2000, p. 103.

Carol Vogel, "Inside Art," *New York Times*, 15 Oct. 1999, p. B32.

John Grande, "James Carl," *Sculpture*, v. 18 no. 3, April 1999, pp. 18–25.

JUSTINA M. BARNICKE GALLERY, UNIVERSITY OF TORONTO

accommodation, 2003/2008. Digital prints on paper. Each 12 x 18 inches.

saws, 2003. Corrugated plastic, vinyl. Each 35 x 48 x 32 inches.

skil, 2003. Corrugated plastic, cardboard, adhesive vinyl, paint. Boxes: 10 x 16 x 14 inches, saws: 9 x 13 x 9.

hebdo, 2008. Aluminum, adhesive vinyl. Each 30 x 30 inches.

woof, 2006. Serpentine. 8 x 8 x 9 inches.

empty orchestra (bi), 1994. Green jade. 4.75 inches diameter. Collection of Margot Lande.

empty orchestra (ba), 1994. Pink marble. 2.5 x 2.5 x 7 inches. Collection of Reesa Greenberg.

empty orchestra (stele), 1994. Chinese black jade. 4 x 7.5 x 1 inches.

empty orchestra (iron), 1994. Marble. 9 x 4.25 x 3.5 inches.

empty orchestra (camera), 1994. Limestone. 2.5 x 5 x 2.5 inches.

takeout (hamburger), 1994–ongoing. Marble. 3 x 5.5 x 5.5 inches. Collection of Paul Bain.

takeout (express), 1994–ongoing. Marble. 2.25 x 2.5 x 2.5 inches.

takeout (coffee), 1994–ongoing. Marble. 3.5 x 3 x 3 inches.

empty orchestra (walkman), 1994. Chinese black jade. 4.75 x 3.5 x 1.25 inches.

empty orchestra (discman), 1994. Chinese black jade. 1 x 5.25 x 5.75 inches. Collection of Margot Lande.

empty orchestra (cell), 1994. Limestone. 9.6875 x 1.8125 x 2.0375 inches. Collection of Shanitha Kachan & Gerald Scheff.

relief, 1997. Cardboard, plexiglass. 40 x 35 x 16 inches.

public works: cardboard only, 1992; *re:possession,* 1990–1994; *re:possession,* 1990–1994. Ink-jet prints, 2008. Each 18 x 24 inches.

t-shirt t-shirt, 2002. Silkscreen on T-shirt. Available in S, M, L, XL.

r-bite (dustbuster), 2003. Cardboard, adhesive vinyl. 16.5 x 4.75 x 4.75 inches.

water flat, 1997. Packaged bottles of water, labels. 8.5 x 16 x 10 inches.

Little Cockroach Press: complete box set, 2000. Cardboard. 8.5 x 6.5 x 2.5 inches. Published by Art Metropole, Toronto.

Little Cockroach Press #8: Legend, 1998. Printed matter. 3 x 7 inches. Published by Art Metropole, Toronto.

4x8_5x7, 2008. Printed matter. 4 x 6 inches. Published by Open Space, Victoria.

Rumours, 2000. Carbonless copy paper. Edition 14/100. 2 x 5 inches.

Gerüchte, 2000. Carbonless copy paper. AP for an edition of 100. 2 x 5 inches.

content 1.0, 2002. Printed matter. 5 x 8 inches. Co-published by Art Metropole and Mercer Union, Toronto.

tv, 1994. Cardboard. 10 x 14 x 9 inches. Collection of Milinda Sato.

cardboard slippers, 1988. Paint, cardboard, hot glue. Men's size 9.

six pack, 1998. Cardboard. 7.5 x 7 x 5 inches.

anon, 1995. Rubber stamp on toilet paper. Unnumbered limited edition. 4 x 4.5 x 4.5 inches.

proofs, 1996. Blank newspaper, rubber stamp. 75 x 12 x 13.5 inches.

the balcony, 2000–2005. Ink-jet prints, 2008. Documentary images of artists' projects by Kristan Horton, Carlo Cesta, Neil Campbell, Marco Breuer, AA Bronson, Andrew Reyes, Hlynur Hallsson. Each 8 1/2 x 11 inches.

r-bite (jigsaw), 2003. Cardboard, adhesive vinyl, paint. 9 x 12 x 3 inches.

thing's end, 2008. Polymer clay, plywood. Installation dimensions: 18 x 192 x 144 inches.

scroll, 2008. Adhesive vinyl. 48 x 76 inches.

CAMBRIDGE GALLERIES, CAMBRIDGE

dupes (X-Ray), 1999. Cardboard. Life size.

dupes (ATM), 1999. Cardboard. Life size.

dupes (FedEx), 1999. Cardboard. Life size.

dynasty, 2001. Corrugated plastic. Life size.

floor models, 2008. Adhesive vinyl. Dimensions variable.

MACDONALD STEWART ART CENTRE, GUELPH

office work '08, 2008. Foamcore, adhesive vinyl, banker's boxes. Dimensions variable.

bone perdue, 1993. Paper. 10 x 12 inches.

the future of sound, 1995. Photocopy on paper. 18 x 24 inches.

self portrait, 1997. Laser print on acetate. 8.5 x 11 inches.

badger, 2009. Adhesive vinyl. 46 x 47 inches.

rastafries (super size), 1998. Adhesive vinyl on corrrugated plastic. 24 panels, each panel 18 x 24 inches.

one potato, 2006. Adhesive vinyl, 45 x 26 inches.

international blues, 2004. Adhesive vinyl on aluminum. 4 panels, each panel 10 x 10 inches.

manners (r, g, b), 2004. Adhesive vinyl on aluminum. 3 panels, each panel 16 x 16 inches.

coop, 2002. Adhesive vinyl on aluminum. 18 x 18 inches.

alchemy, 1998. Adhesive vinyl on masonite. 2 panels, each panel 18 x 24 inches.

banner, 2009. Adhesive vinyl. 226 inches x 49.5 inches.

seven bottles, 2009. Piezo print on paper. Seven panels, each panel 24 x 24 inches.

this, 2008. Adhesive vinyl on aluminum, 30 x 30 inches.

CONCURRENT EXHIBITION AT DIAZ CONTEMPORARY, TORONTO

jalousie (bananier), 2008. Venetian blinds. 66 x 114 x 60 inches.

jalousie (bole), 2008. Venetian blinds. 120 x 48 x 48 inches.

jalousie (baluster), 2008. Venetian blinds. 66 x 96 x 60 inches.

jalousie (roman), 2008. Venetian blinds. 66 x 72 x 48 inches.

jalousie (pin), 2008. Venetian blinds. 64 x 42 x 24 inches.

mongrel, 2007. Piezo print on adhesive vinyl. Variable dimensions.

universal, 2008. Plexiglass on plexiglass. 16 x 16 inches.

double negative, 2008. Latex paint. 48 x 70 inches.

p. 10

dynasty, 2000. Corrugated plastic, cardboard, wood replicas of the 1956 Toshiba automatic rice cooker. Edition of six. Life size.

p. 11

content 1.0, 2002. Artist's book with drawings of common product bottles including a CD-ROM of the corresponding downloadable font (mac and pc compatible). Toronto: Art Metropole and Mercer Union. ISBN 0920956688. 88 pages. 5 x 8 inches.

p. 12

a trophy (for Tom Dean), 1996. Cardboard. 65 x 30 x 23 inches.

p. 16

2%, 1997. Corrugated plastic. Each unit 30 x 11 x 11 inches. View of the exhibition *Face Value,* PS 122, New York, NY, 1997.

p. 17

spring collection, 1991. Anti-freeze bottles, coloured mineral water. 120 inches in diameter.

p. 18

osmosis, 2004. Sponges. Produced in conjunction with Artexte, Parc Jeanne Mance, Montreal.

p. 19

Left to right: *empty orchestra (ba),* 1994. Pink marble. 2.5 x 2.5 x 7 inches. *empty orchestra (cell),* 1994. Limestone. 9.6875 x 1.8125 x 2.0375 inches. From a series of stone replicas of common electronic prosthetics, carved at the Central Academy of Fine Art, Beijing.

p. 20

takeouts, 1995–present. Chinese white marble. Life size. From an ongoing series of hand carved replica takeout containers.

p. 21

t-shirt t-shirt, 2002. Silkscreen on cotton. Available in S, M, L, XL. Originally produced in conjunction with Instant Coffee.

p. 22

View of the exhibition *jalousie* at Galerie Heinz Martin Weigand, Karlsruhe, Germany, 2007.

p. 26

fountain (detail), 1997. Nine vending machines, backlit photo mural, bottled water. 72 x 360 x 33 inches. Commissioned by the Toronto Sculpture Garden.

p. 27

re:possession, 1990–1994. Salvaged cardboard appliance packaging reconfigured to replicate the original package contents. View of the exhibition *unentitled* at YYZ Artists' Outlet, Toronto, 1994.

p. 28

the space between angry lovers in a moving car, 2006. 38 x 70 x 36 inches. View of the exhibition *negative spaces* at Florence Loewy, Paris, France, 2006.

p. 29

jalousie (pin), 2008. 64 x 42 x 24 inches. View of the exhibition *jalousie* at Diaz Contemporary, Toronto, 2008.

p. 30

office work '08, 1999–2008. Foam board, adhesive vinyl, bankers boxes. Reconfigured version of a work originally created for the exhibition *Spatial Interest,* Workspace, New York, 1999.

p. 31

thing's end, 2008. Polymer clay. Boxed edition of 13 life-sized rubber bands.

p. 32

dupes (x-ray), 1999. Cardboard. Life size. One from a series of three cardboard replicas of public service interfaces created for the New York Public Art Fund exhibition, *New Urban Sculpture,* Metrotech Center, Brooklyn, New York, 1999.

p. 34–35

re:possession, 1990–1994. Salvaged cardboard appliance packaging reconfigured to replicate the original package contents. Galerie Clark, Montreal, 1992.

pp. 36–37

re:possession, 1990–1994. Salvaged cardboard appliance packaging reconfigured as package contents. Street view, Montreal, 1990.

p. 39

re:possession, 1990–1994. Salvaged cardboard appliance packaging reconfigured to replicate the original package contents. Galerie Clark, Montreal, 1992.

pp. 40–43

re:possession, 1990–1994. Salvaged cardboard appliance packaging reconfigured to replicate the original package contents. Installation view of the exhibition *unentitled* at YYZ Artists' Outlet, Toronto, 1994.

pp. 44–47
public works: cardboard only, 1993. Cardboard. 50 x 76 x 28 inches. Grunt Gallery, Vancouver, 1993.

p. 49
relief, 1997. Cardboard. 40 x 35 x 16 inches.

pp. 50–51
white walls, 1998–ongoing. Corrugated plastic tires from an ongoing pile. Installation view of the largest pile (approximately 75 units) currently owned by the Art Gallery of Ontario, Toronto. Other piles in private collections, Canada, USA, Germany. Originally shown at Galerie Clark, Montreal, 1998

p. 52–55
Foreground: ***saws,*** 2003. Corrugated plastic, vinyl, wood. Each 35 x 48 x 32 inches. Background: ***accommodation,*** 2003. Laser prints on paper. Installation views of the exhibition *plot* at Contemporary Art Gallery, Vancouver, 2003.

p. 56
skil, 2003. Corrugated plastic, cardboard, vinyl, paint. Edition of six. Boxes: 10 x 16 x 14 inches; saws: 9 x 13 x 9 inches.

p. 57
dynasty, 2000. Corrugated plastic, cardboard, wood. Edition of six. Life size. Replicas of the 1956 Toshiba automatic rice cooker. .

pp. 58–59
r-bite (grinder), 2003. Cardboard, adhesive vinyl, paint. One work from a series of life size replica studio tools. Conceived as a project booth for the Frankfurt Art Fair, 2003.

pp. 60–61
deck, 1995. Limestone. Life size.

p. 62
empty orchestra (stele), 1994. Chinese black jade. 4 x 7.5 x 1 inches. From a series of stone replicas of common electronic prosthetics, carved at the Central Academy of Fine Art, Beijing.

p. 63
empty orchestra (bi), 1994. Green jade. 4.75 inches diameter. From a series of stone replicas of common electronic prosthetics, carved at the Central Academy of Fine Art, Beijing.

p. 64
Clockwise from top left: ***empty orchestra (iron),*** 1994. Marble. 9 x 4.25 x 3.5 inches. ***empty orchestra (walkman),*** 1994. Chinese black jade. 4.75 x 3.5 x 1.25 inches. ***empty orchestra (ba),*** 1994. Pink marble. 2.5 x 2.5 x 7 inches. ***empty orchestra (cell),*** 1994. Limestone. 9.6875 x 1.8125 x 2.0375 inches. From a series of stone replicas of common electronic prosthetics, carved at the Central Academy of Fine Art, Beijing.

p. 65
empty orchestra (discman), 1994. Chinese black jade. 1 x 5.25 x 5.75 inches. From a series of stone replicas of common electronic prosthetics, carved at the Central Academy of Fine Art, Beijing.

p. 66
takeout (hamburger), 1994–ongoing. Chinese white marble. 3 x 5.5 x 5.5 inches. From an ongoing series of hand carved replica takeout containers.

p. 67
Left to right: ***takeout (coffee),*** 1994–ongoing. Marble, 3.5 x 3 x 3 inches. ***takeout (express),*** 1994–ongoing. Marble. 2.25 x 2.5 x 2.5 inches. From an ongoing series of hand carved replica takeout containers.

p. 68
woof, 2006. Serpentine. Life size.

pp. 70–71
spring collection, 1991. Anti-freeze bottles, coloured mineral water. 120 inches in diameter.

pp. 72–73
redemption, 1993. Beer cans, shopping cart.

pp. 74–75
escalation, 1994. Awning fabric. State Theater, New Brunswick, New Jersey. 1994.

pp. 76–77
fountain, 1997. Nine vending machines, backlit photo mural, bottled water. 72 x 360 x 33 inches. Commissioned by the Toronto Sculpture Garden.

pp. 78–79
2%, 1997. Corrugated plastic. Each unit 30 x 11 x 11 inches. View of the exhibition *Face Value*, PS 122, New York, NY, 1997.

p. 80

concession, 2002. Pink and white adhesive vinyl. Window alteration at the Art Gallery of Ontario, Toronto.

p. 82-83

osmosis, 2004. Sponges. Produced in conjunction with Artexte. Outdoor installation at Parc Jeanne Mance, Montreal.

p. 84

proposed monument for a clover leaf, 2002. Fibreglass. 84 inches in diameter.

p. 86

jalousie #1, 2006. Venetian blinds, bucket. 53 x 24 x 25 inches.

p. 88

jalousie (the space between letters on a page), 2007. Venetian blinds. 40 x 50 x 28 inches.

p. 89

jalousie (the space around shadows), 2007. Venetian blinds. 31 x 43 x 33 inches.

p. 91

jalousie (envy), 2006. Venetian blinds. 44 x 39 x 30 inches.

pp. 92–93

jalousie (slug), 2007. Venetian blinds. 34 x 47 x 26 inches.

pp. 94–96

jalousie (baluster), 2008. Venetian blinds. 66 x 96 x 60 inches.

p. 99

jalousie (roman), 2008. Venetian blinds. 66 x 72 x 48 inches.

pp. 100–101

Left: *jalousie (bananier),* 2008. Venetian blinds. 66 x 114 x 60 inches. Right: *jalousie (bole),* 2008. Venetian blinds. 120 x 48 x 48 inches. Installation view at Diaz Contemporary, Toronto.

pp. 102–103

thing's end, 2008. Polymer clay. 18 x 192 x 144 inches. A series of replica rubber bands displayed on oversized plywood plinth.

p. 105

Foreground: *thing's end,* 2008. Polymer clay, plywood. Installation dimensions: 18 x 192 x 144 inches. Background: *scroll,* 2008. Adhesive vinyl. 48 x 76 inches.

pp. 106–107

Installation views at Justina M. Barnicke, University of Toronto. See exhibition checklist for full list of works.

pp. 108

From left to right: *bone perdue,* 1993. Paper. 10 x 12 inches. *the future of sound,* 1995. Photocopy on paper. 18 x 24 inches. *self portrait,* 1997. Laser print on acetate. 8.5 x 11 inches **badger,** 2009. Adhesive vinyl. 46 x 47 inches. *rastafries (super size),* 1998. Adhesive vinyl on corrrugated plastic. 24 panels, each panel 18 x 24 inches.

pp. 109

Left: *seven bottles,* 2009. Piezo print on paper. Seven panels, each panel 24 x 24 inches. Right: *banner,* 2009. Adhesive vinyl. 226 inches x 49.5 inches.

pp. 110-111

office work '08, 2008. Foamcore, adhesive vinyl, banker's boxes. Dimensions variable.

pp. 112–113

Left to right: *dupes (X-Ray),* 1999. Cardboard. Life size. *floor models,* 2008. Adhesive vinyl. Dimensions variable. *dupes (ATM),* 1999. Cardboard. Life size.

pp. 114–115

Left: *dupes (ATM),* 1999. Cardboard. Life size. Right: *dynasty,* 2001. Corrugated plastic. Life size.

p. 117

dupes (FedEx), 1999. Cardboard. Life size.

伐柯伐柯 其則不遠

Published by Justina M. Barnicke Gallery, Hart House, University of Toronto; Cambridge Galleries; and Macdonald Stewart Art Centre on the occasion of the exhibition *James Carl: do you know what, a survey 1990–2008*.

Justina M. Barnicke Gallery
Hart House, University of Toronto
7 Hart House Circle
Toronto, ON M5S 3H3 Canada
www.jmbgallery.ca
Director / Curator: Barbara Fischer
Exhibition Coordinator: Katie Bethune-Leamen
Gallery Staff: Tejpal Ajji, Christopher Régimbal, Maiko Tanaka, Jenna Winter

The Justina M. Barnicke Gallery operates under the auspices of Hart House at the University of Toronto. It is supported by the University of Toronto and the Canada Council for the Arts and receives project support from the Department of Canadian Heritage, the Ontario Arts Council and Toronto Arts Council. Programs are supported through inter-institutional collaborations and grants or donations from foundations, corporate sponsors and individuals.

Cambridge Galleries
Queen's Square
1 North Square
Cambridge, ON N1S 2K6 Canada
www.cambridgegalleries.ca
Director: Mary Misner
Curator: Ivan Jurakic
Curator, Architecture and Design: Esther E. Shipman
Education Officer: Robert Thody
Audience Development Coordinator: K. Jennifer Bedford

Cambridge Galleries are supported by membership, the City of Cambridge, Canada Council for the Arts and the Ontario Arts Council.

Macdonald Stewart Art Centre
358 Gordon Street
Guelph, ON N1G 1Y1 Canada
www.msac.ca
Director / Curator: Judith Nasby
Assistant Curator: Dawn Owen
Gallery Coordinator: Verne Harrison
Administrative Assistant: Nina Berry
Education Coordinator: Aidan Ware

The Macdonald Stewart Art Centre is supported by its sponsors: the University of Guelph, City of Guelph, County of Wellington and Upper Grand District School Board; by memberships and donations; by foundations and grants from the Guelph Community Foundation through the Musagetes Fund, from the Ontario Government through the Ontario Arts Council, and from the Federal Government through the Canada Council for the Arts and the Department of Canadian Heritage.

Copy Editors: Rosemary Heather, Bryne McLaughlin
Photography: Merle Addison, Isaac Applebaum, Toni Hafkenscheid, Jane Kidd, Jon Langille, Paul Litherland, Dean Palmer, Josef Schulz, Althea Thauberger, Sean Weaver
Catalogue Management & Design: Chris Kennedy, Sarah Robayo Sheridan
Digital Image Preparation: Clarity
Printer: Friesens
Publication © 2009 Justina M. Barnicke Gallery, Hart House, University of Toronto
Artwork © 2009 James Carl
Texts © 2009 Robert Enright, Barbara Fischer, Ivan Jurakic
Design © 2009 Chris Kennedy, Sarah Robayo Sheridan

Library and Archives Canada Cataloguing in Publication

James Carl : do you know what : a survey, 1990–2008.
Essays by Robert Enright, Barbara Fischer and Ivan Jurakic. Catalogue of an exhibition held in three separate venues: Justina M. Barnicke Gallery, Toronto, Ont., Nov. 22, 2008-Jan. 25, 2009, Macdonald Stewart Art Centre, Guelph, Ont., Jan. 17-Mar. 22, 2009 and Cambridge Galleries, Cambridge, Ont., Jan. 17-Mar. 1, 2009. Co-publ. by: Cambridge Galleries and Macdonald Stewart Art Centre.
ISBN 978-0-7727-6072-2

1. Carl, James, 1960- --Exhibitions. I. Enright, Robert II. Fischer, Barbara, 1956- III. Jurakic, Ivan, 1967- IV. Justina M. Barnicke Gallery V. Macdonald Stewart Art Centre VI. Cambridge Galleries
N6549.C354A4 2009 709.2 C2009-900538-7

Distributed by ABC Art Books Canada
www.abcartbookscanada.com
Printed in Canada